IMAGES
of America

BOSTON RADIO
1920–2010

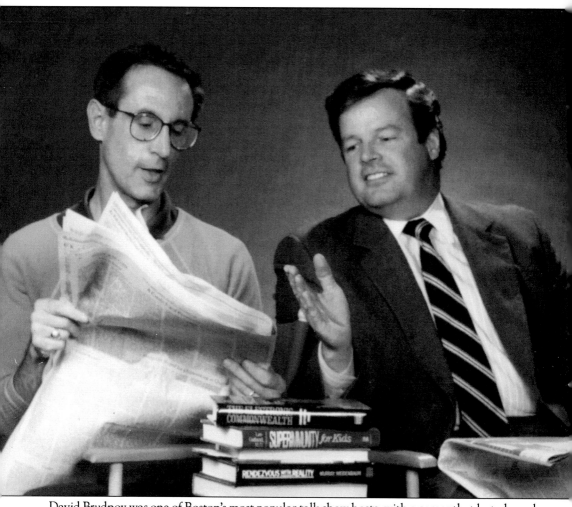

David Brudnoy was one of Boston's most popular talk show hosts, with a career that lasted nearly two decades. Known for being fair, even to those with whom he disagreed, he also was a theater critic, an author, and a professor. Brudnoy, pictured on the left, is seen with fellow WBZ host and political commentator Peter Meade in 1989. (Courtesy of WBZ Radio.)

ON THE COVER: Arnie "Woo Woo" Ginsburg was the king of AM Top 40 radio, first at WBOS and then at WMEX. In a world of deep-voiced disc jockeys, Arnie's high-pitched voice was unique. He was known for his self-deprecating humor—he often referred to himself as "Old Leather Lungs" and "Old Aching Adenoids"—and for his frequent use of sound effects, which included bells, whistles, and a foghorn. (Courtesy of Arnie Ginsburg.)

IMAGES
of America

BOSTON RADIO
1920–2010

Donna L. Halper

ARCADIA
PUBLISHING

Published by Arcadia Publishing
Charleston, South Carolina

Printed in the United States of America

Library of Congress Control Number: 2010932745

For all general information, please contact Arcadia Publishing:
Telephone 843-853-2070
Fax 843-853-0044
E-mail sales@arcadiapublishing.com
For customer service and orders:
Toll-Free 1-888-313-2665

Visit us on the Internet at www.arcadiapublishing.com

*I dedicate this book to Boston's devoted radio listeners
and to the researchers who preserve radio's history.*

CONTENTS

ACKNOWLEDGMENTS

Many people contributed to making this book a reality. I would like to first thank Aaron Schmidt of the Boston Public Library for going above and beyond for me many times. I would also like to thank the promotion directors and general managers of current Boston radio stations, including WBUR, WEEI, WGBH, WKLB, WMJX, WODS, WRKO, WROR, WTKK, and WXKS-FM, for their cooperation; and a special thank-you to Peter Casey and Nick Darling of WBZ for all their assistance. Thanks to Cha-Chi Loprete for the WZLX and WBCN photographs and to Joe Mazzei for the Sunny Joe White photographs. Among the others who offered advice and/or donated photographs were Bob Bittner, Steve Elman, John H. Garabedian, Ken Johnson, Sam Kopper, Dave Kruh, Maurice Lewis, Duncan MacDonald, Joe Martelle, Fred McLennan, Jimmy Myers, Harry Nelson, Candy O'Terry, Norm Thibeault, and J. J. Wright.

Among the family members who helped me are Eunice Stolecki, who provided photographs of AMRAD/WGI and of her late aunt Eunice Randall; Helen Miller, who provided photographs of her late husband, Mel Miller, as well as Ed Hider of the old WMEX; and Bev Kennedy, who provided photographs of her late husband, Bob Kennedy of WBZ. I am indebted to Bryan Benilous at Proquest Historical Databases and Brett Kolcun of Newsbank/Readex; each provided access to numerous historical newspapers and made my research easier to do. Bequaert Old Books was an excellent resource for magazines from the 1920s and 1930s. Thanks also to Henry Scannell and the staff of the Boston Public Library's microfilm room, as well as the reference librarians at the Thomas Crane Public Library in Quincy. I am eternally grateful to my husband, Jon Jacobik, who scanned many of the photographs for me and provided ongoing encouragement. And finally, I want to thank my editor at Arcadia, Erin Rocha, for believing in this project and helping to move it forward.

INTRODUCTION

In our Internet-oriented world, most people take radio for granted. It has become just one of many ways to get music, news, and sports. Today not many Americans rely on one favorite station, nor do many children have a favorite disc jockey, which is the complete opposite of when I was growing up. From the time I was a kid, when my mother introduced me to WHDH—her favorite station and the home of Ken and Bill, Bob and Ray, Bob Clayton, and Fred B. Cole—radio provided the sound track of my life. The disc jockeys were like friends to me; some of my favorites were Arnie Ginsburg on WMEX, Bruce Bradley and Jefferson Kaye on WBZ, Wild Man Steve on WILD, and Uncle T on what was then WTBS, which is WMBR today. I collected Top 40 surveys and eagerly read magazine articles about my favorite stations. And I dreamed that one day I would have a radio career of my own.

These days radio still has plenty of fans; however, it is not the "magical medium" that it once was. And yet, for those of us who grew up with it, radio does possess a certain magic. Those who are new to our city quickly find that local radio is an important part of being a Bostonian. Doomsayers may predict radio's demise, but the neighborhood kids are listening to their favorite stations just as I did. And while much about the broadcasting industry has changed, Boston's tradition of great stations and great personalities continues even now.

Most people believe that WBZ, which is the oldest surviving station in Massachusetts (and still uses its original call letters), was Boston's first station. But in reality, it was the second. It was, however, the first station to receive the newly created "commercial license" from the Department of Commerce. WBZ went on the air in mid-September 1921, with a live broadcast from the Eastern States Exposition. But WBZ was not a Boston station during its early years. Back then, it was located 90 miles away, in the Westinghouse Electric and Manufacturing plant in Springfield. Despite its good signal, many listeners in the eastern part of the state could not receive WBZ very well, and many of the big-name entertainers who performed in Boston were unable, or unwilling, to make the trip out to Springfield. That is why WBZ finally opened a Boston station in late February 1924; it received the call letters WBZA, with studios in the Hotel Brunswick.

But in 1921, as Bostonians adjusted the dials of their radios, they were not listening for WBZ. Most likely what they heard was Greater Boston's first and only station, 1XE, with studios in Medford Hillside about 4 miles from Boston. 1XE had been broadcasting sporadically since late 1919. Although it was located on the campus of Tufts College, it was not a college station; 1XE was owned by the American Radio and Research Corporation (AMRAD), which had been founded by two Tufts graduates, Harold Power and Joseph Prentiss. In addition to 1XE, there were two other pioneering stations that began broadcasting in 1920—8MK in Detroit (today known as WWJ) went on the air in late August, and KDKA in Pittsburgh made its official debut on November 2.

In those early days, stations were called "radiophones," and radio was still referred to as "wireless." And much like people today with their iPods, radio listeners back then needed headphones to

hear what was being "sent through the ether." A fan of broadcasting was a "radio bug," and Boston had plenty of them. Most early listeners were also ham radio hobbyists who knew Morse code, were able to build their own sets, and enjoyed trying to pull in distant stations, which was a game called "radio golf," and also known as "DX'ing." During radio's first several years, stations had no formats. They used block programming, which is 10 or 15 minutes of one kind of program, followed by 10 or 15 minutes of something entirely different. But most listeners did not mind the lack of consistency because radio was changing their lives in very positive ways. Unlike the newspapers, radio was immediate, so for the first time, anyone could find out about an event as it was happening. And thanks to radio, entertainment became more widely available. It did not matter if listeners were rich or poor, rural or urban; anyone could enjoy the broadcasts without leaving the comfort of home.

In early February 1922, Greater Boston's only station was still 1XE, and it was now known as WGI, or the AMRAD station. WGI was the first station in the region to offer a daily newscast, beginning in mid-February. It was also the first to broadcast police reports of stolen cars, read by the station's pioneering female announcer, Eunice Randall. A talented "draftslady" who did technical drawings for AMRAD, Eunice was the first female announcer in Massachusetts and one of the first in the United States. WGI was the first home of "Big Brother" Bob Emery, who went on to a long career as a children's show host, first in radio and then television. Among the entertainers who became local celebrities by performing at WGI were bandleader Joe Rines and vocal duo Hum and Strum (Tom Currier and Max Zides). And by April 1922, a number of Tufts College professors began broadcasting lectures on subjects ranging from engineering to history to literature, making it one of the earliest experiments in education by radio.

But although WGI was innovative, it had a small budget and no more than 100 watts. Radio stations were expensive to run without a major corporate backer, and airing commercials to help defray the cost was not yet a common practice. In fact, Herbert Hoover, then head of the Department of Commerce, said he wanted radio to remain noncommercial. When WGI tried to broadcast a car commercial in April 1922, the Department of Commerce told the station never to do that again. Yet despite the expense, new radio stations were coming on the air all over the country, including new stations in Boston.

In late July 1922, a major change occurred when a new station made its debut from studios in the Shepard Department Store in downtown Boston. Its call letters were WNAC, which is still around today and known as WRKO. But when it first went on the air, it was often called the "Shepard Station." The station was financially supported by wealthy entrepreneur and local business executive John Shepard III, whose family ran successful department stores in Boston and Providence. The Providence Shepard store became the home of WEAN, which was run by John's brother Robert. But unlike WGI, where everyone volunteered, John Shepard III was able to pay for talent. He sought out the best performers and announcers, even if they worked elsewhere. Several members of WGI's staff, tired of volunteering, left to go to WNAC and make a respectable salary.

Shepard instituted some practices still in use today, such as "house names." His women's show was done by Jean Sargent, which was not the announcer's real name, and when the original Jean, who was actually a businesswoman named Bertha Mitchell, left the station in 1925, her replacement was also named Jean Sargent. WNAC provided Sunday church services from St. Paul's Episcopal Church, which was greatly appreciated by the elderly and shut-ins. And in January 1924, in a gesture that was truly unique for its time, the Shepard station became the first in Boston to broadcast synagogue services, live from Temple Israel, where Rabbi Harry Levi led the congregation. Back then, few Christians had the opportunity to listen to a rabbi discussing Jewish beliefs, so WNAC contributed to teaching tolerance. Rabbi Levi, to his great surprise, became somewhat of a radio star, with numerous listeners, most of whom were not Jewish, coming to his synagogue to ask for his autograph.

It did not take long for WNAC to become a major player in Boston radio, and WGI was having trouble keeping up. Another blow occurred in September 1924 when WGI's biggest star, "Big

Brother" Bob Emery, left to become program manager of Boston's newest station, WEEI. Owned by the Edison Electric Illuminating Company, WEEI quickly went after WNAC's audience. Edison had a budget for talent too, and now there was intense competition to see which station would win over the best-known performers. Adding to the intensity of this scenario was the fact that, since late February 1924, Westinghouse had a presence in Boston, and WBZA was also competing for Boston talent. By 1925, the Boston radio dial was dominated by WBZ, WNAC, and WEEI, with WGI no longer a player. Boston's first station, which is all but forgotten today, went bankrupt in mid-1925, and its staff quickly scattered to the other stations.

By the mid-1920s, contrary to Herbert Hoover's wishes, most stations were airing commercials, and a number of programs were sponsored. There were two national networks, NBC (1926) and CBS (1927), both of which used sponsorships to pay for the biggest names in entertainment. Local radio was doing well too. Not only were Boston listeners hearing their favorite singers and announcers, but also an increasing number of sporting events were on the air. WNAC had been broadcasting college football in 1923, and WBZ was the first station to do hockey, starting in late 1924. Baseball had to wait till April 1926, when WNAC began broadcasting some of the Red Sox and Braves games. *Boston Traveler* sportswriter Gus Rooney was Shepard's first sports announcer, followed later by local favorite Fred Hoey. As the 1920s came to an end, both college and professional sports were staples of Boston radio.

In early 1931, several local stations were on the move. WNAC and its new sister station (formerly WLEX in Lexington but renamed WAAB after being purchased by Shepard) were now located in beautiful studios in Kenmore Square at the Buckminster Hotel. WEEI was relocating from 39 Boylston Street to bigger and more expansive studios at 182 Tremont Street, which is owned today by Emerson College. WBZA not only moved, relocating to the Hotel Bradford in the theater district, but also got a new name. In late February, Westinghouse flipped the call letters of WBZ in Springfield and WBZA in Boston, and the Boston station became known as WBZ, with the WBZA call letters given to the Springfield station. Being in Boston had been very successful for Westinghouse, and giving the Boston station the WBZ call letters reflected that success.

During the 1930s, when America was in the midst of the Great Depression, radio was more important than ever. In such a difficult time, hearing famous entertainers on the air provided listeners with an escape. In May 1930, John Shepard III helped many regional stars to reach a bigger audience by creating the Yankee Network, which soon had affiliates all over New England. This was also good news for stations in smaller cities, which now had access to Boston's big-name talent. And by the spring of 1934, Shepard had come up with another addition to the Yankee Network—the Yankee News Service, which offered newscasts delivered by a team of experienced reporters. Nationally, there was a new network, called Mutual, and Boston had several new stations that included WHDH, which was originally a Gloucester station that opened Boston studios in late 1930. In October 1934, WMEX, formerly known as WLOE, went on the air, and in August 1935, WCOP debuted. Also, in April 1936, the former WBSO, originally from Wellesley, moved to Boston as WORL. And although it was in Lawrence, WLAW, which signed on in December 1937, also had some Boston fans.

But the other news was the arrival of what inventor Edwin Howard Armstrong called "static-free radio," or what is called FM today. Always ahead of the curve, John Shepard III put Greater Boston's first frequency-modulated station, W1XOJ, on the air in late July 1939. By December 1940, it had been linked with a New Hampshire FM, W1XER, creating the first FM network. In November 1943, the Federal Communications Commission assigned FM stations the kind of call letters that AM stations had. But while audiophiles saw FM's possibilities, the general public did not, and few people bought FM receivers. It would be several decades before FM became as popular as AM.

In late March 1941, the government changed the frequencies of many radio stations nationwide. Among those that moved were WLAW to 680 on the AM dial, WHDH to 850, WORL to 950, WBZ to 1030 (where it remains today), WNAC to 1230, and WMEX to 1510. WEEI was still at 590, and WCOP was still at 1150. In the early 1940s, the most powerful station was WBZ, with

50,000 watts; most of the other stations in town had between 500, like WCOP, and 5,000 watts, like WEEI and WNAC.

After World War II ended, there were a number of new AM stations on the air, including WBMS (November 1946) and suburban stations WKOX in Framingham (April 1947), WJDA in Quincy (September 1947), WLYN in Lynn (December 1947), WCRB in Waltham (January 1948), WTAO in Cambridge (April 1948), and WVOM in Brookline (June 1948). When Emerson College put WERS-FM on the air in November 1949, Boston also had one of the first noncommercial, educational FMs in the United States. And one other big change to the Boston AM dial occurred in June 1953, when WLAW, owned by the *Lawrence Eagle-Tribune*, went off the air. WNAC was able to move into the 680 frequency, where it still remains to this day. But John Shepard III, who had long been unhappy with WNAC's dial position, did not live to see it. He died in mid-June 1950, and today few radio listeners know how his innovative spirit affected Boston radio. He was perhaps the first owner to hire an all-female staff to try home-shopping in 1927, the first to get radio journalists the same credentials as those of newspaper reporters in 1934, and among the few owners who believed in FM.

The big news in the 1950s was the emergence of Top 40, and by 1956, Arnie "Woo-Woo" Ginsburg was playing it on WBOS, the former WVOM. In September 1957, under new owners, WMEX gradually changed formats and was soon playing the hits, as was WCOP. By the end of the 1950s, Ginsburg had moved his *Night Train* show to WMEX, where it quickly became even more popular. WBMS was sold, and the new owners changed the call letters to WILD in the autumn of 1957. By the summer of 1961, WILD became the first station in the area to focus on the black audience, playing gospel and rhythm and blues.

The 1960s saw several major changes to the Boston radio dial. For one, FM finally began to appeal to a wider audience. In March 1968, former classical music station WBCN started playing what was then called "progressive rock" and went entirely to this format in 1969. Unlike the short versions of songs that were heard on AM Top 40 stations, FM played longer versions, and announcers on FM used a more laid-back style than the frenetic Top 40 disc jockeys did. But AM Top 40 was not dead. A new station, WRKO, formerly WNAC, had burst onto the scene in March 1967 and quickly became Boston's dominant station, although WMEX, WBZ, and others were still playing hit music. WBZ's version of Top 40 was softer and jokingly called "chicken rock"; the station catered to its adult listeners with an evening talk show. And as Boston radio enjoyed its 50th year, there was more change on the horizon. By the 1970s, the battle between AM and FM would intensify, with more new stations and music formats on the FM band, which, in turn, forced the AM dial to reinvent itself as a medium for news, sports, and talk.

One

THE FORMATIVE YEARS

Greater Boston radio grew quickly during the 1920s, as a number of new stations went on the air. Some were short-lived like WAAJ and WFAU, both of which debuted in mid-1922, and neither of which lasted a year. Others, like WEEI, WBZ, and WNAC, quickly proved they were here to stay. Some were low-powered like WAGS in Somerville, which went on the air in 1926 with 5 watts. Others were high-powered like WBZ, which had 5,000 watts the same year. Some stations were owned by churches, like the Tremont Temple Baptist Church's WSSH with its *Strangers' Sabbath Home* program, and some by newspapers, like the *Boston Evening Transcript*'s WBET. Some, like WSSH and WBET, had requested call letters. Others just took the ones they were assigned (it is a myth that Gloucester's WHDH stood for "We haul dead haddock"). Some, like WBZA, had beautiful studios in a hotel, while others, like WBBG in Mattapoisett or WLEX in Lexington, debuted from their owner's home.

Some stations, like WEEI and WNAC, had few problems winning a large audience. Others, like WBET, struggled with persistent technical failures and never earned the public's trust. WBET debuted with much fanfare in late 1927, but its owners gave up and sold it by early 1929. There were also stations that tried to serve their community but were removed from the air by the new Federal Radio Commission (FRC). In 1928, the FRC decided the airwaves were too crowded and deleted more than 100 small stations, including Quincy's first, WRES, in Wollaston.

It was in the 1920s that a number of local performers first gained popularity. Among them were Charles L. H. Wagner (the "Radio Poet") and local bands like Bernie and His Bunch and Ted and His Gang. Even announcers now had fans—WBZ's John Shaw Young was so popular that he was wooed away by the new National Broadcasting Company.

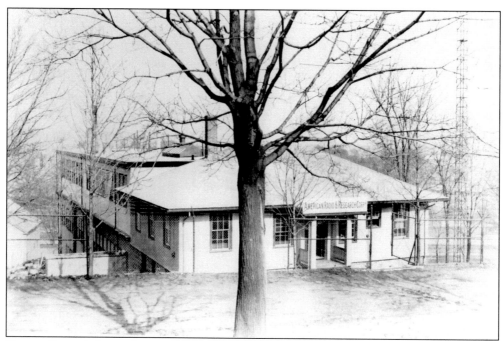

Greater Boston's first radio station was the AMRAD station, 1XE (later known as WGI), with studios on the campus of Tufts College at Medford Hillside. In the early 1920s, 1XE's announcers and engineers spent their days working in the AMRAD factory designing and building radio equipment. Then, in the evening (most broadcasts at that time were only at night), various members of the staff took their turns broadcasting. 1XE's slogan was "AMRAD: The voice of the air." These photographs, taken in 1921, show two exterior views of the AMRAD plant. (Both, courtesy of Eunice Stolecki.)

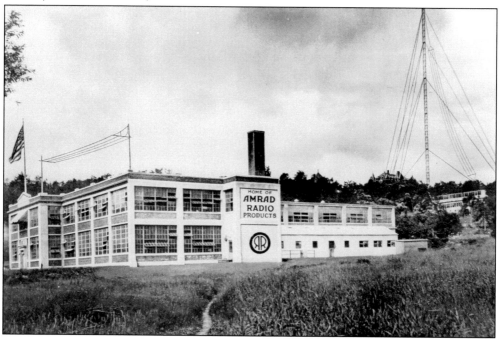

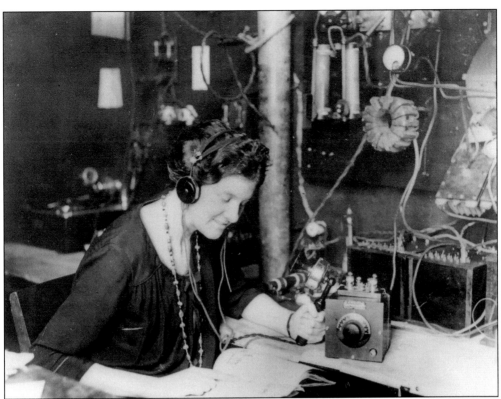

This 1921 photograph, taken in the AMRAD studio, shows Eunice Randall (later Eunice Randall Thompson), Boston's first female announcer. A talented broadcaster, she read bedtime stories to children, announced the musical selections, and read the news. (Courtesy of Eunice Stolecki.)

WIRELESS TELEPHONE CONCERT, WEDNESDAY EVENING
Nov. 9,1921

Victor Records obtained through the courtesy of M. Steinert & Sons, 35 Arch St., and 162 Boylston St., Boston, Mass.

1. President Harding March
 United States Marine Band 18768-A

2. Nightingale and the Rose
 Soprano Mabel Garrison 64978

3. Humpty Dumpty
 Comic Duet - Billy Murray-Ed Smalle 18610-A

4. Scherzo (van Goens)
 Cello Victor Herbert 64298

5. The Want of You
 Tenor Edward Johnson 64985

6. Hungarian Rhapsody, No. 2
 Philadelphia Symphony Orchestra
 Leopold Stokowski, Conductor 74647

7. Virginian Judge, Part 1
 Walter C. Kelly in Southern Court Scene
 All characters which you hear in these two
 numbers are impersonated by Walter Kelly alone 45250-A

8. Virginian Judge, Part 2 45250-B

9. When It's Springtime in Virginia
 Women's Quartet 17437-B

10. Tuck Me to Sleep in My Old 'Tucky Home
 Fox Trot- Benson Orchestra of Chicago 18829-A

11. Drowsy Maggie- Medley of Reels
 Irish Pipes, Patrick J. Touhey 18639-A

12. Love Sends a Little Gift of Roses
 Baritone- Reinald Werrenrath 64954

Here is a rare 1921 playlist from 1XE. While most radio stations offered live music, sometimes phonograph records were played. The records were often obtained by barter; a local record shop would provide them in exchange for an on-air mention during the broadcast. (Courtesy of Eunice Stolecki.)

WBZ's studios were originally at the Westinghouse factory on Page Boulevard in Springfield. Unfortunately for the performers, early studios were often cramped and uncomfortable, and broadcasts took place under less than ideal conditions. In this 1921 photograph, the man with the headphones is station engineer and announcer Horace R. Dyson. His job was to make sure nothing went wrong with the equipment while the vocalist and her accompanist performed. Few stations had attractive studios back then, and the performers probably did not expect something aesthetically pleasing. But as time passed, performers began to request a studio audience or a room that looked more welcoming. Radio stations began building more professional studios, and WBZ was no exception, opening a new studio at the Hotel Kimball. (Courtesy of WBZ Radio.)

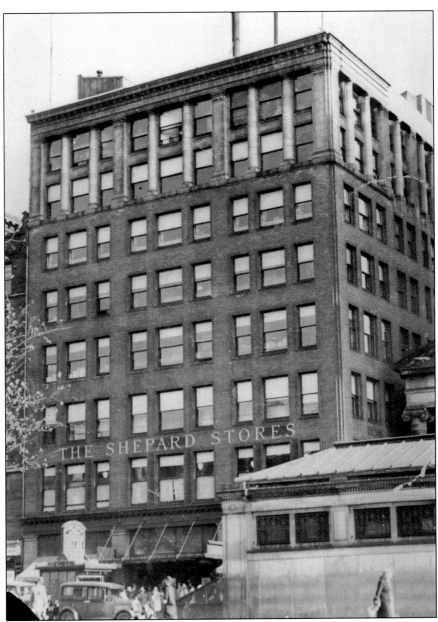

THE SHEPARD STORES

The Shepard Department Store was originally known as the Shepard-Norwell Company. It was founded by John Shepard Sr. in 1865 and sold mainly dry goods. As the times changed, the store expanded into appliances and furniture, in addition to clothing. By the time the radio craze came along, the Shepard store was already selling radio equipment. Both John Shepard Jr. and John Shepard III believed the time was right for a radio station, and the Boston store seemed like the perfect place to build it. They hoped radio fans would come to the store to watch the live broadcasts—and then make some purchases. By mid-1922, the entire fourth floor was set aside for radio studios, and in late July, WNAC went on the air as the "Shepard Station." Many of the store's employees also became broadcasters, including Shepard himself, who occasionally did some announcing. This photograph shows the exterior of the Shepard store located at Winter and Tremont Streets. (Courtesy of Boston Public Library.)

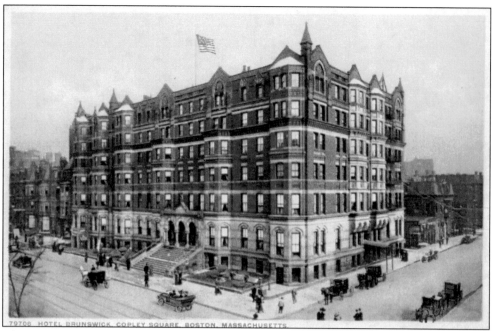

This postcard shows an early view of the Hotel Brunswick, located at Boylston and Berkeley Streets. The Brunswick opened in 1874, and in 1918, a new ballroom, called the Egyptian Room, was added. This ballroom was where people danced to the music of Leo Reisman and his Hotel Brunswick Orchestra. WBZ's Boston studio (WBZA) opened at the Brunswick in late February 1924, with bandleader Leo Reisman and a number of other local stars providing the music. (Author's collection.)

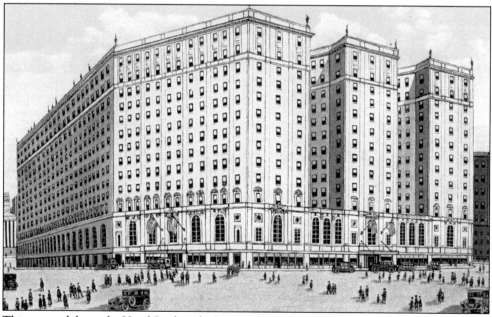

This postcard shows the Hotel Statler, which opened in Park Square in March 1927. WBZ broadcast the hotel's opening celebration, featuring Bert Lowe's Hotel Statler Orchestra. WBZA relocated to the Statler later in June. (Author's collection.)

As the radio craze spread, listeners sought ways to praise their favorite stations. Not everyone had a telephone, so the Dictograph Company printed "applause cards" that were available at radio and record shops. Fans mailed the card to a radio performer whose program they had enjoyed. A show's popularity was often determined by how many applause cards it received. The photograph below shows examples of another popular fad—collecting EKKO stamps. Whenever listeners received a distant station, they wrote to ask for a verification stamp, which they then placed in a special album. Collectors bragged about how many EKKO stamps they had. (Both, author's collection.)

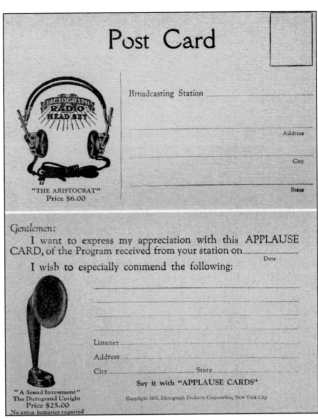

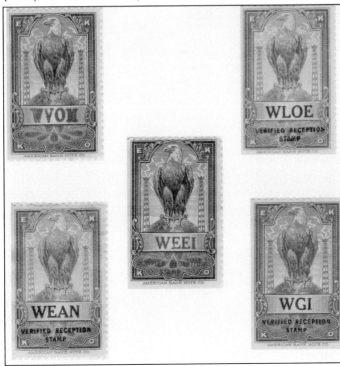

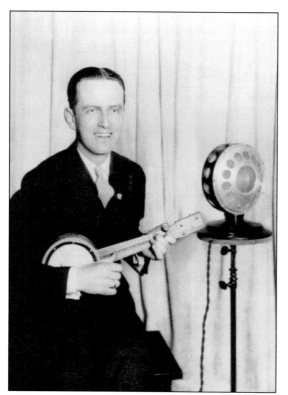

Although "Big Brother" Bob Emery was known as a television entertainer, his first two decades were spent in radio. He began his career as a singer and announcer at 1XE/WGI in 1921 and launched the Big Brother Club in early 1924. With his trademark banjo, he performed children's songs, accompanied by the Joy Spreaders. He also read stories and acted in skits. This 1924 photograph shows him at the WGI microphone. (Courtesy of Boston Public Library.)

In September 1924, Emery left for the new WEEI, where he became the station's program director. The Big Brother Club continued to grow, with a membership card, official pin, and club outings at local parks and zoos. This October 1925 photograph shows Emery in the WEEI studios. (Courtesy of NSTAR Archives.)

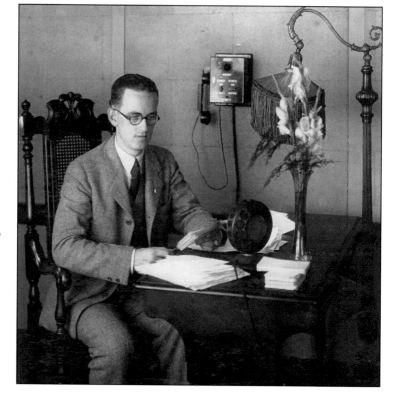

Gordon Swan did not plan a radio career. As a teenager, he had performed dramatic skits on WGI and later did some announcing, but his intention was to study art or theater. One night, he heard on WBZ in Springfield that they needed an announcer at the new Boston studio, WBZA. He auditioned and was hired at a salary of $1.50 a week. Westinghouse soon transferred him to Springfield, and by 1926, he was WBZ's studio director. In mid-1927, Swan returned to Boston as the assistant program director for WBZA. He also became known for creating sound effects for the station's radio dramas. The 1924 photograph at right shows him at WGI. Reminiscing about his long career, Gordon is pictured below in 1997 at age 93. (Right, author's collection; below, courtesy of *Quincy Patriot-Ledger*.)

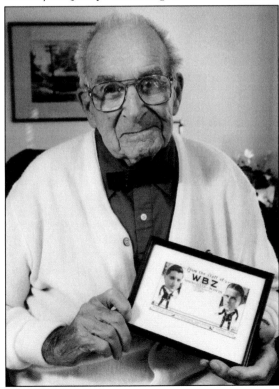

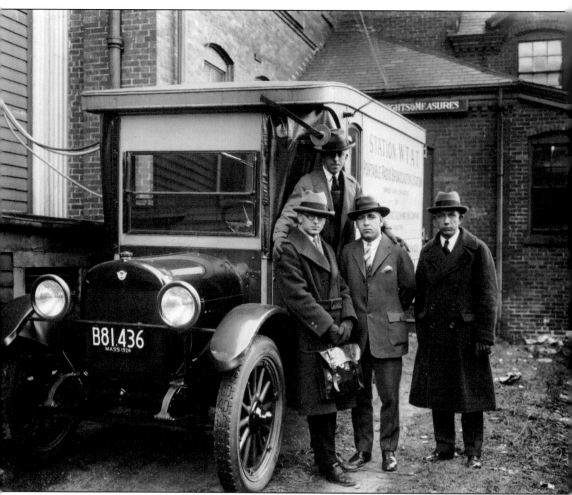

In radio's early days, not every city had its own station, but there was great demand for local broadcasts. Some entrepreneurs created portable stations, which traveled in a truck and were set up at county fairs or local events. One portable station, WCBR, was a frequent visitor to theaters in Lynn and Roslindale from 1924 to 1925. The best known portable station was WTAT, a 100-watt station that belonged to the Edison Electric Illuminating Company. By 1926, the call letters were changed to WATT. Before WEEI got its license, Edison used WTAT when broadcasting at trade shows or conventions. In 1928, the new Federal Radio Commission removed portables from the air because their signals often interfered with other stations. In this 1924 photograph, a team of two announcers and two engineers are ready to broadcast from Watertown Town Hall. (Courtesy of NSTAR Archives.)

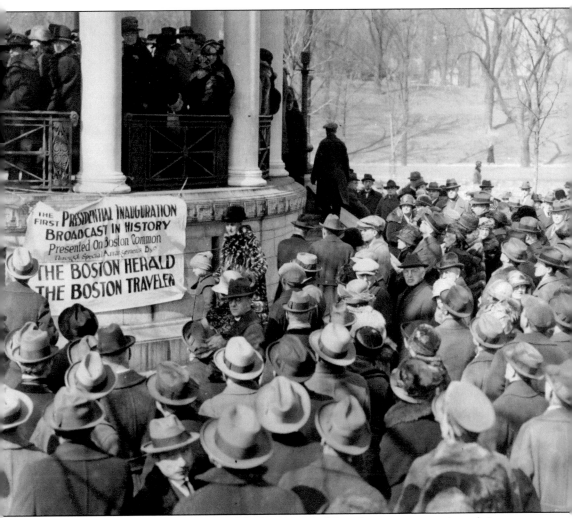

One of the amazing things that radio did for listeners was bring them to an event in real time, as it was happening. In March 1925, when Pres. Calvin Coolidge was inaugurated, there was great interest in Boston, since Coolidge had formerly been governor of Massachusetts. This was the first time a presidential inauguration was broadcast, and a number of stations nationwide linked up to make it possible. In Boston, WEEI carried the event, and for those who were not near a radio, there were loudspeakers set up in various places to relay the broadcast. Unfortunately, this caused major traffic jams, as large crowds spilled into the street. This 1925 photograph shows some of the throngs on Boston Common who gathered to listen. (Courtesy of Boston Public Library.)

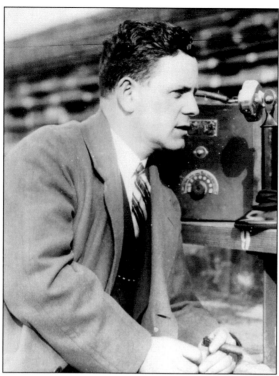

When WNAC began broadcasting the Red Sox games in April 1926, John Shepard III called upon Augustine "Gus" Rooney of the *Boston Traveler* to do play-by-play. Gus had an extensive knowledge of sports, having worked as a baseball umpire and a football referee, as well as a sports reporter. In 1926, he also announced some National League Boston Braves games and an occasional boxing match. This photograph shows Gus at the microphone. (Courtesy of Boston Public Library.)

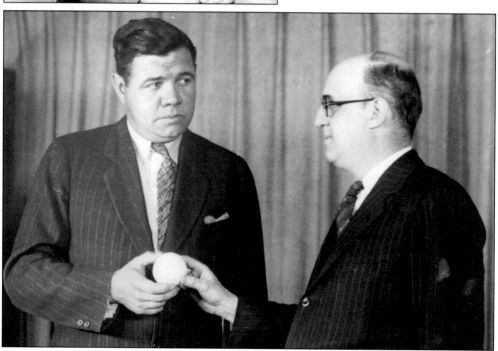

This 1927 photograph shows George Herman "Babe" Ruth (left) with John Shepard III. Throughout the 1920s, the popular ballplayer was heard on the radio raising funds for charities or giving talks to young fans. He also campaigned on behalf of Democratic presidential candidate Al Smith. (Courtesy of Boston Public Library.)

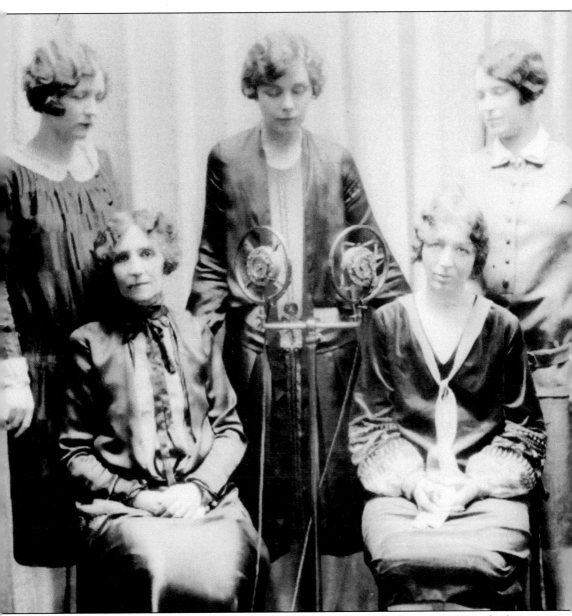

John Shepard III was an innovator, and the creation of station WASN in January 1927 was further proof of this. The call letters stood for "Air Shopping News," and Shepard hoped to do a version of home shopping. In the pre-television era, nobody expected to see the merchandise, except in newspaper advertisements, so he hired broadcasters who could describe it. The announcers were all female, perhaps the first time this had ever occurred. In addition to reports from major department stores, WASN featured tips on fashion and advice about saving money. There were also interludes for music and news. The WASN experiment proved unsuccessful, but most of its announcers continued to work in radio. Those pictured are, from left to right, (first row) Jane Day and Dorothy Dean; (second row) Ruth Winslow, station manager Marion Smith, and Grace Lawrence. (Courtesy of Boston Public Library.)

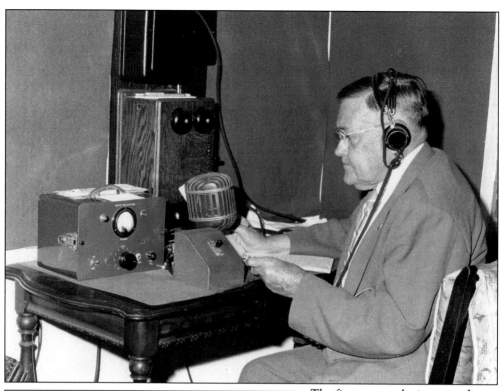

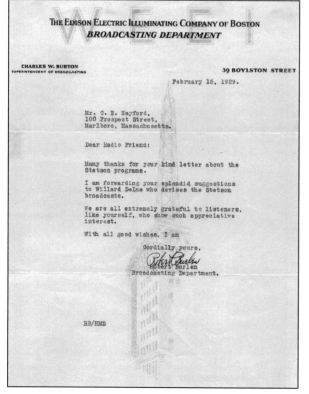

The first meteorologists on radio came from the United States Weather Bureau, which included Boston's Edward Burton Rideout, better known as E. B. Rideout. In mid-1925, he gave a well-received series of educational talks on WEEI about understanding atmospheric conditions. Soon he was delivering WEEI's daily weather reports, the start of a 38-year career. In the undated photograph above, E. B. Rideout is seen at the microphone. (Courtesy of Boston Public Library.)

Here is a 1929 response to a fan letter about a program on WEEI. Weymouth's Stetson Shoe Company was sponsoring an award-winning local American Legion band, which performed every Sunday night. The listener's suggestion was forwarded to Willard de Lue, the account executive for Stetson. De Lue was also a reporter for the *Boston Globe*. (Author's collection.)

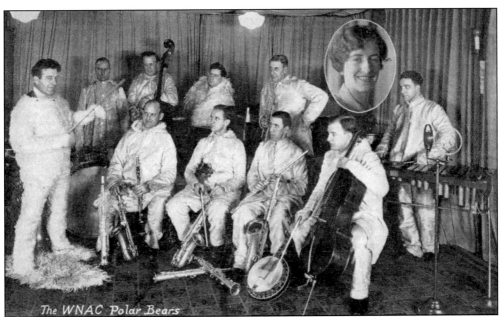

The WNAC Polar Bears

Many stations tried to find clever names for their artists. In 1928, WNAC introduced the Polar Bears, who were actually local entertainers heard on the station under various other names. Here is a postcard of the group dressed in costume that was sent out to fans; bandleader Charles R. Hector is at left, and the unidentified woman is either Jane Day or Jean Sargent. (Author's collection.)

In this photograph is "Molly Malone," a member of the Polar Bears as well as an actress. She was one of the WNAC Players, someone who performed radio dramas. Molly Malone was a house name; some sources believe one woman who used to be Molly was Priscilla Fortescue. (Author's collection.)

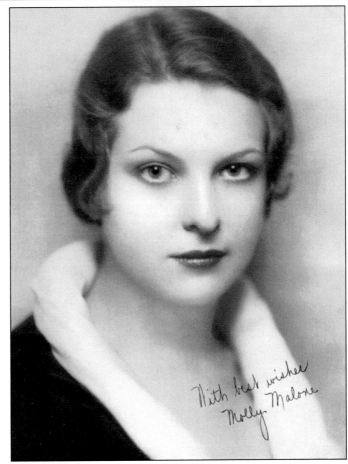

With best wishes
Molly Malone

As far back as early 1921, newspaper columnists wrote about radio; one of the first was Guy Entwistle in the *Boston Traveler*. A popular radio editor was the *Boston Post*'s Howard Fitzpatrick, whose columns began in August 1928. Because he knew the performers and the announcers, he offered inside information that fans looked forward to reading. (Courtesy of Boston Public Library.)

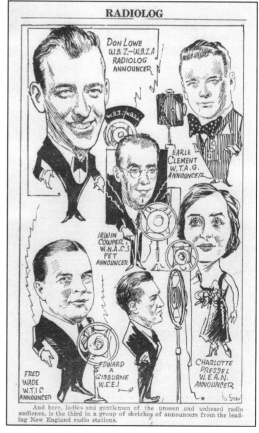

Radio listeners often wondered what the performers and announcers looked like, so local newspapers and magazines published photographs and caricatures of Boston-area stars. This February 1932 illustration from the *Radiolog* magazine shows some popular announcers, including Medal of Honor recipient Edward Gisburne. He had lost a leg during the war and started a successful new career as a radio announcer in 1928. (Author's collection.)

Two

RADIO'S GOLDEN AGE

As the United States endured the Great Depression, radio kept the nation informed and entertained, while giving the public much-needed escape. All the network stars could be heard locally. Bostonians especially enjoyed comedians like Fred Allen (born John Florence Sullivan in Cambridge), who was a national star with his own NBC show. They were also proud of local boy Harry Einstein, whose character Nick Parkyakarkus was heard on Eddie Cantor's program. There was even a new network called Mutual. But in addition to popular comedies and dramas, more people were listening for news. Nationally, President Roosevelt turned to radio for his "fireside chats." Locally, John Shepard III, who had fought for the right of radio reporters to get the same press credentials as print reporters, had the Yankee News Service up and running.

A number of Boston stations, including WBZ and WEEI, expanded their news, and during natural disasters like the floods in 1936 and the hurricane in 1938, Boston's radio stations offered crucial information. Sometimes a local incident became a national story. In late 1931, John L. Clark, program director of WBZ, decided to install a purity code, which would ban songs with questionable lyrics. One of the songs he decided to ban was regularly performed by bandleader Joe Rines, who did not think the song was questionable at all. Their feud made some national news. So did another event in April 1932. At WBZ's new Hotel Bradford studios, a live audience gathered to watch a performance featuring King Leo, a supposedly trained circus lion. But Leo somehow broke free from his cage and rampaged through the studio, injuring five and terrifying the 200 guests.

WEEI began to be operated by CBS under a lease agreement. In addition to new stations like WORL and WMEX on the AM dial, Boston also got its first FM station when Shepard's W1XOJ went on the air in July 1939. Although few people had FM receivers, the station got Shepard some publicity.

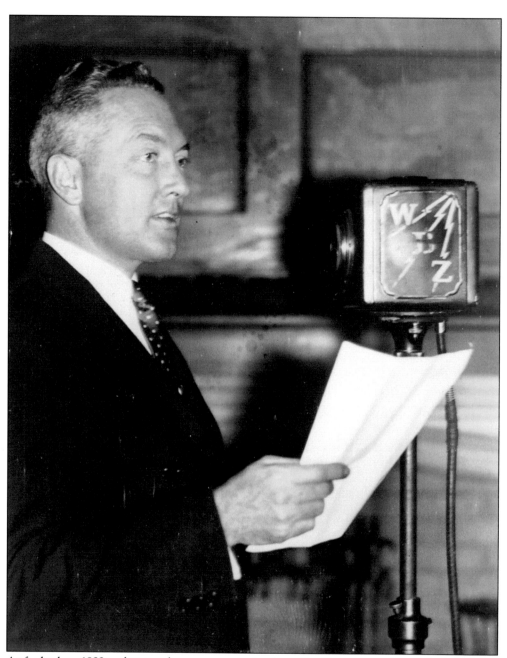

As far back as 1922, politicians began campaigning by radio. Contrary to the myth that he was "Silent Cal," Calvin Coolidge used radio during his years in the White House. He also occasionally spoke on the air in favor of Republican candidates. Coolidge got involved in the 1930 fight for governor, telling WBZ and WBZA listeners to reelect Gov. Frank Allen. But Democratic challenger Joseph Ely also used radio successfully, getting his message out via WEEI, WNAC, and WBZ. In this photograph, probably from 1932, newly elected Governor Ely is giving a talk at WBZ in Boston. (Courtesy of WBZ Radio.)

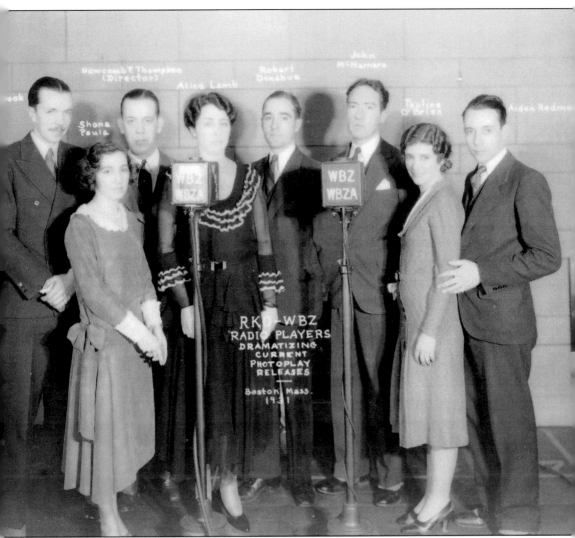

When live radio plays became popular, WBZ was among the stations with its own dramatic troupe. The WBZ Players began in 1928, with a staff that included director Thomas H. McNally, Robert White, and Esther Riner. By 1929, the director was Wayne Henry Latham, formerly with WBET (the *Boston Evening Transcript* station), with his wife, Ruth, acting in some of the plays. John W. Holbrook is pictured at left in 1931; by the year's end, he had left for NBC. He went on to win a good diction medal from the American Academy of Arts and Letters. Also pictured is Newcomb F. Thompson, the radio editor of the *Boston American*. He wrote and produced some of the plays for WBZ, which were not only performed on radio, but at theaters in both Boston and Springfield. (Courtesy of WBZ Radio.)

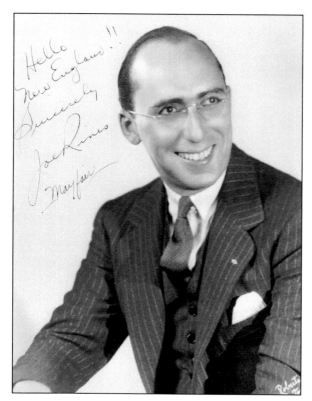

Among the local bandleaders who attained national prominence was Joe Rines, whose career was launched at WGI in 1922. Another was Jacques Renard, who was first heard on Boston radio beginning in the mid-1920s. At left is a publicity shot of Joe Rines. He began as the violinist with Bernie and His Bunch. His band's name changed with the sponsor—for a while it was the Triadors (for Triad Radio Tubes). (Author's collection.)

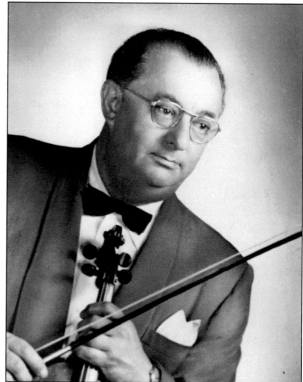

This undated photograph shows Jacques Renard. Raised in Chelsea, he was advised to change his name, Jacob Staviski, to something more continental. Renard was known for his girth (often weighing around 250 pounds) as well as his talent. (Author's collection.)

Other popular local bandleaders of the era included Charles Rennard Hector and Lloyd G. Del Castillo. The photograph at right, probably from 1932, is of Hector, whose St. James Theater Orchestra was heard on WBZ and WNAC during the mid-1920s. He went on to become the leader of the Polar Bears on WNAC before going to WEEI. The photograph below, also probably from 1932, shows Del Castillo, an organist who got his start in theater. His orchestra became a fixture on WEEI. In the late 1930s, he was named a regional director of educational programming for CBS. (Both, author's collection.)

In radio's early years, announcers used initials rather than names, a holdover from amateur radio. One well-known voice was "E. F. A." of WBZ and WBZA. His real name was Arthur F. Edes, and he became WBZA's chief announcer in 1924. In September 1925, he joined WEEI, where he became program director. This photograph is probably from 1932, the year Edes was also hired by Emerson College; he created the broadcasting department and taught radio announcing. (Author's collection.)

Arthur Edes announced the Boston Symphony Orchestra's concerts and often conducted interviews with local news makers. In this photograph, Edes is shown at the WEEI microphone. (Courtesy of Emerson College Archives.)

Robert A. Burlen developed his performing skill while at Dartmouth College, where he acted in plays and cowrote songs for musicals. His career blossomed when he joined the staff of WEEI; he wrote comic skits, produced musical comedies, and did some announcing. In 1928, he became a member of the Boston version of the *I. J. Fox Fur Trappers* program. This image, probably from 1932, is his publicity photograph for the *Hobby Show*. (Author's collection.)

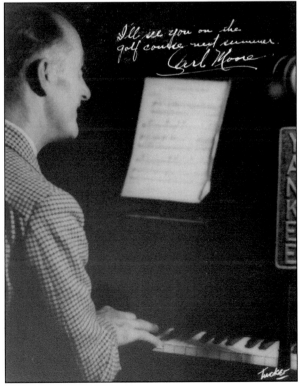

Carl Moore performed in vaudeville before WNAC hired him in 1926. A Boston radio favorite, he was known for singing old-time songs and standards. He later worked for WEEI, hosting *Beantown Matinee* and *Beantown Varieties*. In this photograph from the early 1930s, he is at the microphone of the Yankee Network. (Author's collection.)

John Shepard III's interest in radio definitely paid off. By 1930, the Yankee Network was up and running with affiliates throughout New England. He was hiring more local talent, and by August 1936, he began the Colonial Network. He was also putting an FM station on the air. But not everything was positive. Late in 1937, the Boston Shepard Department Store suddenly closed. And in 1939, one of Shepard's Boston stations, WAAB, which would later move to Worcester, had its license challenged. Shepard was accused of airing editorials in support of candidates, something that was frowned upon by the FCC, which expected radio stations to remain objective. This photograph is the one that he frequently used in newspapers during the 1930s. (Courtesy of Boston Public Library.)

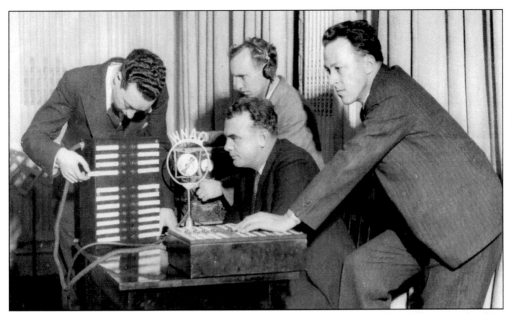

By the early 1930s, most stations had mastered the complex art of remote broadcasts. In this late October 1931 photograph, WNAC's Linus Travers (left) is shown with Gerry Harrison (right) and two other Yankee Network staffers as they prepare to broadcast a Boston College football game. (Author's collection.)

This 1931 photograph shows Fred Hoey, a former sportswriter who began doing baseball play-by-play for WNAC in 1927. Hoey and John Shepard III had a contentious relationship, but every time Shepard tried to fire him, the fans objected. (Courtesy of Boston Public Library.)

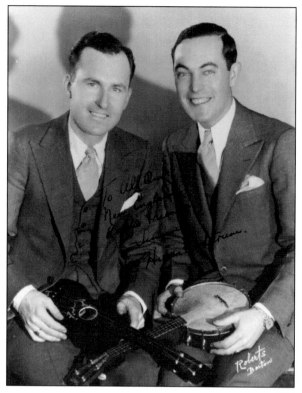

Shown here in this undated photograph are "Hum and Strum" (Max Zides and Tom Currier), who got their start at WGI in 1924. At first, Max (Hum) played the ukulele, but eventually he and Tom (Strum) focused on their trademark smooth harmonies. The duo was heard on WBZ for several decades. Another radio star with longevity was Georgia Mae (Georgia Mae Harp). A popular country vocalist, she was known for her triple yodel and her white guitar. Her radio career began at WORL in the late 1930s, and she then got her own program on WBZ. Below is a promotional postcard she sent to fans. (Both, author's collection.)

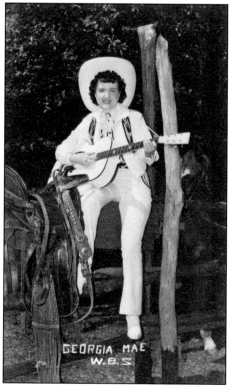

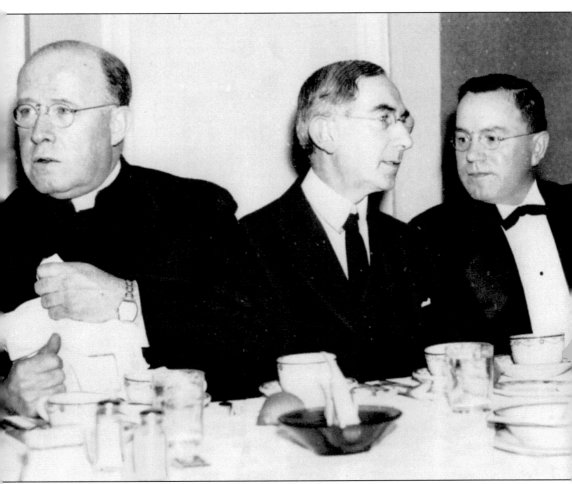

Boston stations had broadcast religious services as early as 1922, featuring preachers of all denominations. This 1938 photograph shows two of Boston's best-known clergymen, Fr. Michael J. Ahern (left) and Rabbi Harry Levi (center), sitting with Rev. John Ratcliffe. Long before religious tolerance became fashionable, Rabbi Levi used radio to promote a better understanding of what Jews believed. People of all faiths listened to his sermons on WNAC. His friend Father Ahern was an equally tireless campaigner for tolerance. He and Rabbi Levi, often with Episcopal bishop Henry Knox Sherrill, held panel presentations promoting interfaith understanding. Father Ahern, a scientist with expertise in geology, also had his own WNAC program, the *Catholic Truth Hour*. (Courtesy of Boston Public Library.)

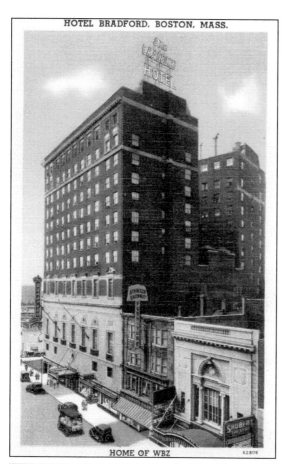

HOTEL BRADFORD, BOSTON, MASS.

HOME OF WBZ

WBZ Radio had a new transmitter in Millis and was broadcasting with 25,000 watts when the station moved to the Hotel Bradford (formerly the Elks Hotel) in July 1931. This postcard, sent to fans, noted that the Bradford was now the home of WBZ. (Author's collection.)

WNAC and the Yankee Network also relocated in 1931, moving to the Buckminster Hotel in Kenmore Square, shown in this postcard. Shepard's plan was to not only use the hotel and its beautiful ballroom but to also expand into several adjoining buildings. When the construction was completed, there would be 11 studios available to WNAC and Yankee Network personnel. (Author's collection.)

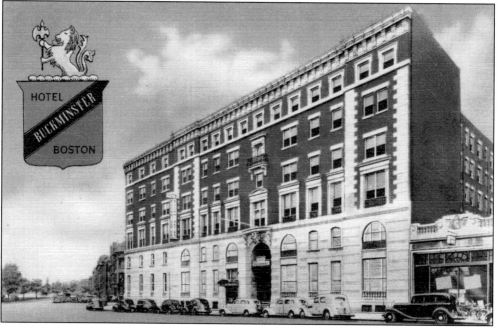

HOTEL BUCKMINSTER BOSTON

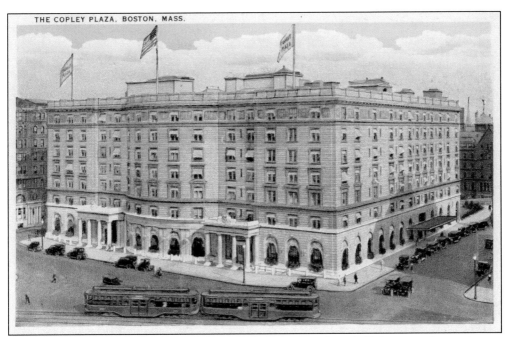

THE COPLEY PLAZA, BOSTON, MASS.

WCOP was originally licensed as WMFH, but when owner Joseph Kirby opened it in August 1935, it had new call letters and studios in the Copley Plaza Hotel. Kirby died suddenly in 1937, and WCOP was sold to Arde Bulova and Harold Lafount. This postcard shows an early view of the Copley Plaza, which opened in 1912 as a luxury hotel. (Author's collection.)

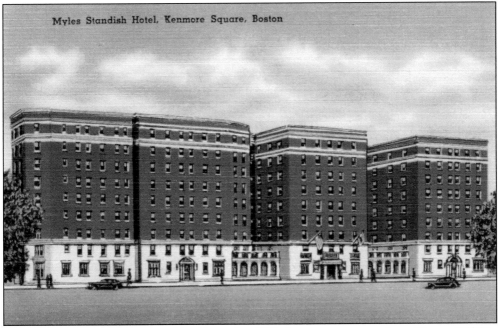

Myles Standish Hotel, Kenmore Square, Boston

When WBSO in Wellesley was sold in December 1935, the new owners got the call letters WORL, and the studios were moved to the Myles Standish Hotel in April 1936. WORL became known for its local programming at a time when much of Boston radio was relying on network shows. This postcard shows the Myles Standish, which opened in 1928. (Author's collection.)

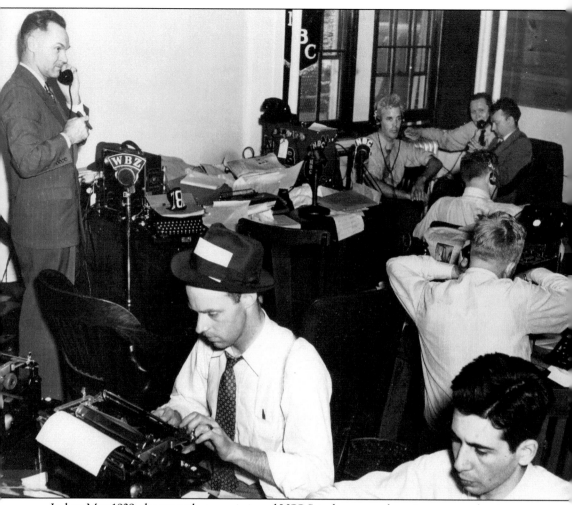

In late May 1939, the recently commissioned USS *Squalus* navy submarine was conducting a test of its ability to submerge rapidly, which was useful in avoiding enemy detection. But something went terribly wrong, and the *Squalus* unexpectedly sank in the waters not far from Portsmouth, New Hampshire. Despite heroic rescue efforts, 26 men died, making it the third worst submarine disaster in naval history. As the story unfolded, New Englanders turned to their radios for news. WBZ reporters were first on the scene in New Hampshire, where they provided eyewitness accounts as the rescue mission took place. Days later, WBZ broadcast the memorial service. Shown is the 1939 WBZ newsroom, where reporters for the station as well as for NBC were gathering the latest information. (Courtesy of WBZ Radio.)

Alfred and William Poté were involved with several Boston radio stations, beginning with WRSC (Radio Shop of Chelsea), which became WLOE and moved to Boston in December 1927. After WLOE lost its license, the brothers put WMEX on the air in mid-October 1934; they owned it until 1957. Among the area broadcasters who got their start at WMEX were weatherman Don Kent and jazz expert Nat Hentoff. Pictured at right in his later years is Alfred J. "Al" Poté, a station manager of WMEX. He was also an engineer and helped to develop some of the first television tubes. (Courtesy of Boston Public Library.)

William S. "Bill" Poté was president and general manager at WMEX. While his brother returned to engineering and invention, Bill remained at WMEX. (Courtesy of Boston Public Library.)

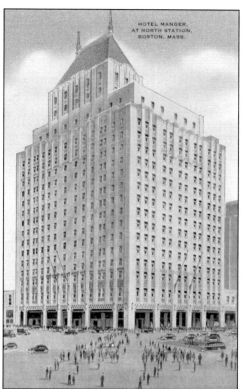

Many radio stations were on the move in the 1930s, either moving to new studios, like the 1931 relocation of WEEI from 39 Boylston Street to 182 Tremont Street, or installing a new transmitter, like WBZ in Millis in 1931. This postcard is of the Hotel Manger in North Station, which opened in August 1930. In October 1934, the Poté brothers moved the studios of WMEX to the 18th floor. Eventually the station moved to 70 Brookline Avenue. (Author's collection.)

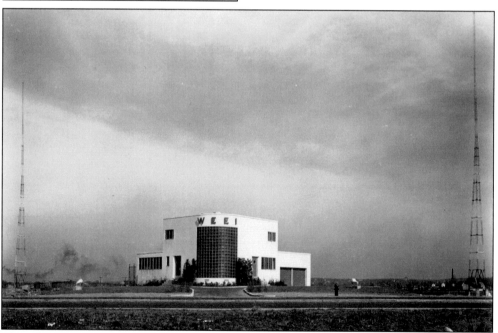

This photograph shows the WEEI transmitter building, which was relocated to Medford in the mid-1930s. In April 1937, former members of 1XE, including Eunice Randall, went there to broadcast a re-creation of early radio, celebrating Medford's contribution to broadcasting. (Courtesy of Boston Public Library.)

Three

A Time of Transition

The 1940s and early 1950s saw many changes in Boston radio. Although World War II had begun, John Shepard III was still trying to interest the public in FM, even establishing a small network, but most people remained loyal to AM. In 1942, CBS officially purchased WEEI, and this was not the only change of ownership to occur. Although WNAC and the Yankee Network, which now had 21 affiliates, celebrated the opening of new and impressive studios in early 1942, Shepard was developing health problems that gradually resulted in his being less involved in broadcasting. In mid-December 1942, WAAB, formerly part of the Colonial Network, moved to Worcester. A few days later, Bostonians were shocked to learn that Shepard had sold all of his radio properties to General Tire and Rubber Company. Although he stayed on as chairman of the board and claimed the programming would stay the same, people were puzzled.

Meanwhile, several other stations had new owners. In 1944, WCOP was sold to the Cowles brothers, newspaper publishers from Des Moines. This arrangement was short-lived; by 1951, the station was for sale again. WORL, a popular independent station, was removed from the air in 1949 due to the financial improprieties of its owners. It returned with a new staff and new ownership in 1950.

After the war, there were a number of new stations. They included Boston's WBMS in November 1946 and suburban stations such as Quincy's WJDA in September 1947, Cambridge's WTAO in April 1948, and Brookline's WVOM (Voice of Massachusetts) in June 1948. The postwar baby boom had begun, and young families were enjoying a new mass medium—television—causing some pundits to predict the death of radio. But radio would not die, although the music it played was about to change. In mid-June 1953, the AM dial changed dramatically when Lawrence's WLAW ceased broadcasting. WNAC moved to the 680 AM frequency, and a new station, WVDA (Victor Diehm Associates) debuted at 1260 AM. In 1957, it was sold and renamed WEZE.

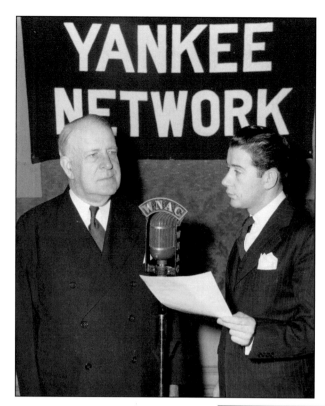

The Yankee News Service used the slogan "News while it IS news." Vincent "Vin" Maloney was an up-and-coming reporter who was only 22 when he was hired by WNAC. This 1941 photograph shows him interviewing state senator David Ignatius Walsh (left). (Courtesy of Boston Public Library.)

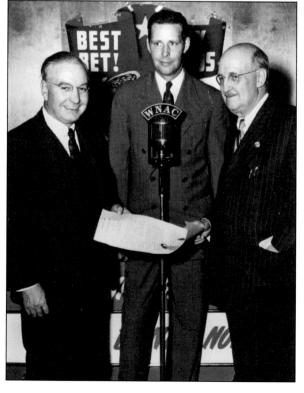

This 1942 photograph was taken at WNAC's 20th anniversary celebration. Those pictured are, from left to right, Massachusetts lieutenant governor Horace T. Cahill, Boston mayor Maurice Tobin, and John Shepard III. Shepard was receiving an official citation. (Courtesy of Boston Public Library.)

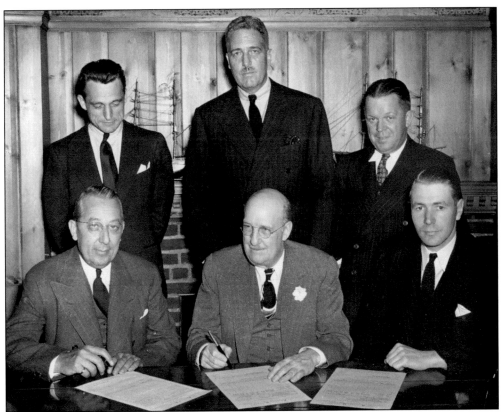

Although the general public was not yet interested in FM, audiophiles were delighted, since it delivered static-free broadcasts and clearer sound. John Shepard III was determined to make FM broadcasts profitable. This 1941 photograph shows him signing the first FM commercial contract with the Socony Vacuum Oil Company. Those pictured are, from left to right, (first row) J. M. Martin (Socony Vacuum), Shepard, and A. L. Nickerson (Socony Vacuum); (second row) John R. Latham (American FM Network), George Walker (Socony Vacuum), and C. A. Snyder (J. Stirling Getchell Advertising Agency). (Courtesy of Boston Public Library.)

Since the expansion of the Yankee Network, the changes in Kenmore Square are visible in this 1946 photograph. The marquee was changed frequently to promote on-air features. (Courtesy of NSTAR Archives.)

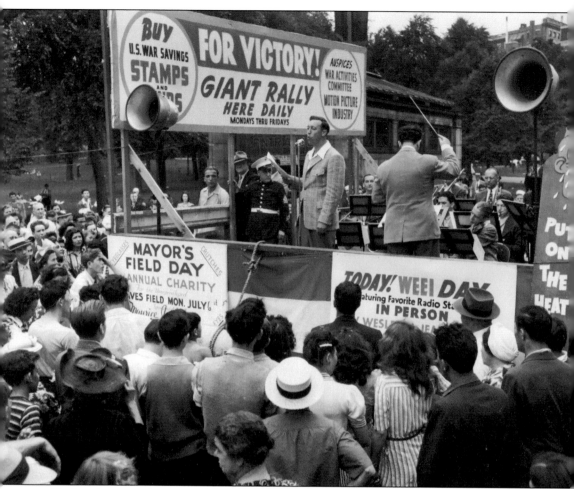

During the war, radio changed dramatically. More female announcers were hired, as many of the men went into the military. Stations played more patriotic songs, and more programs had patriotic themes. Radio performers and news reporters held the nation together, providing listeners with a much-needed escape, while keeping them informed about world events. Many stations, along with their biggest stars, donated air time to raise money for causes that would benefit the country, such as encouraging people to buy war bonds. In this July 1942 photograph, WEEI is taking its turn out on the Boston Common, providing fans with the chance to watch a live broadcast while they make a donation. (Courtesy of Boston Public Library.)

WRUL was a shortwave station that went on the air in the mid-1930s as W1XAL with the goal of fostering international good will. Founded by businessman and inventor Walter S. Lemmon, a vice president at IBM, the station was renamed WRUL (the World Radio University Listeners) in 1939. It featured programs in many languages, all of which stressed peace, tolerance, and cooperation between nations. The 1942 photograph at right shows the Boston studios, located in a brownstone at 133 Commonwealth Avenue. The station offered programming in more than 20 languages. The 1948 photograph below shows station manager Wyman Holmes with Edwin Wesley, assistant director of the *Friendship Bridge*, displaying letters and cards the station had received. (Both, courtesy of Boston Public Library.)

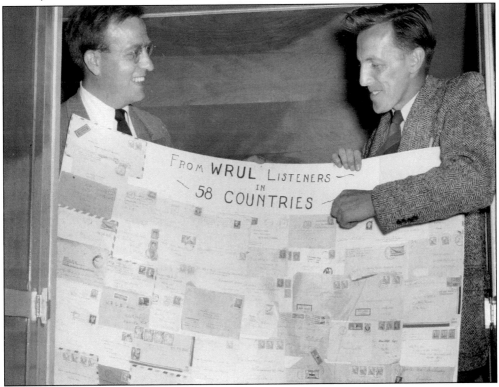

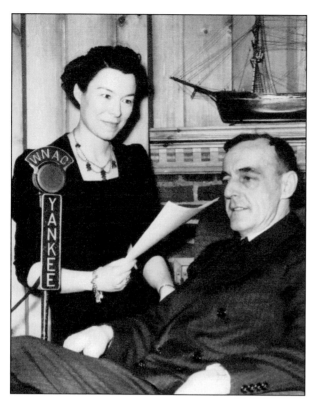

During radio's first 30 years, women were generally not encouraged to be announcers, except on programs aimed at housewives. The first successful "women's show" host was Caroline Cabot, whose program debuted on WEEI in 1926 and lasted for 25 years. Another successful host was Ruth Moss, who began hosting *Ruth Moss Interviews* on the Yankee Network in 1932. She invited celebrities and news makers to be guests on her show. Moss is seen interviewing naval hero Capt. Joseph A. Gainard in this 1940 photograph. (Courtesy of Boston Public Library.)

This photograph shows Louise Morgan, host of a women's show that featured celebrity interviews. Morgan was introduced to radio by Ruth Moss in 1942 and went on to be heard on the Yankee Network throughout the 1940s. In 1949, she began a successful television show, *Shopping Vues*. (Courtesy of Boston Public Library.)

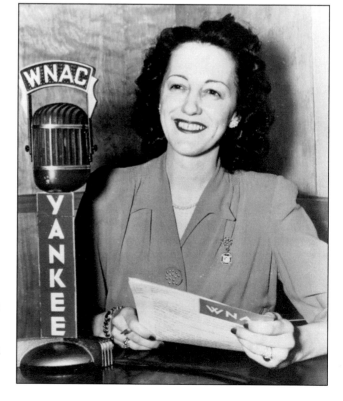

Among the other popular women's show hosts in Boston radio from the 1930s into the 1950s were Priscilla Fortescue and Mildred Carlson. As with other female hosts, they focused on traditional subjects believed to appeal to women. Fortescue hosted two programs on WEEI: *Good Morning, Ladies*, during which she interviewed local women doing interesting things, and *Hollywood Snapshots*, which informed listeners of the latest movie star news. This is a station postcard that she sent out to her fans. (Author's collection.)

This photograph shows Mildred Carlson. She got her start on WBZ in 1930 and continued to host her *Home Forum* program for over two decades. An experienced dietitian and home economist, she had been an instructor at a cooking school and was known for her radio recipes. (Courtesy of Boston Public Library.)

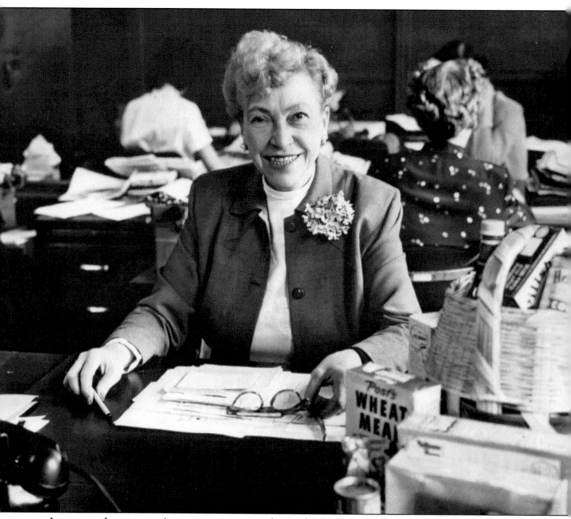

In an era when women's opportunities were limited, Marjorie Mills made the most of her options. In 1916, she became the first woman on the staff of the *Boston Herald*, where she covered Boston's social elites and then moved up to writing features for the women's page. Her recipes were so popular that she soon edited a cookbook. Her radio career began on WNAC in the mid-1920s. She later became the women's page editor for the *Boston Herald*, while continuing to broadcast. She was on WNAC with *The Marjorie Mills Hour* in the late 1930s and early 1940s and then went to WBZ, where she teamed with Carl de Suze for 17 years. This photograph shows her in the *Boston Herald* newsroom. (Courtesy of *Boston Herald*.)

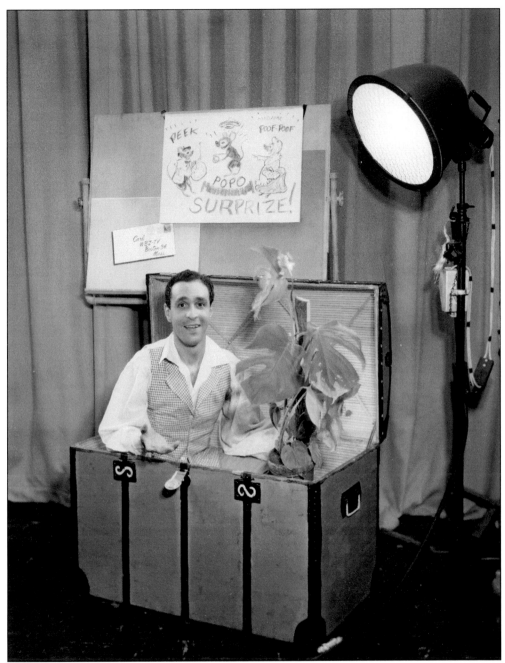

Carl de Suze had worked in Portland, Maine, prior to coming to WBZ in 1942. A true Renaissance man, he was a linguist, a world traveler, and an accomplished chef in addition to being a broadcaster. He always had an interesting story to tell. He was on the air the night of the deadly Cocoanut Grove fire and went to the scene to report on it. He attended the investiture of Pope Paul VI and also gave reports from such countries as Vietnam, Turkey, and Greece. His WBZ morning show quickly reached number one and stayed there. When television came along, de Suze hosted WBZ-TV's first children's program. In this 1948 photograph, Carl de Suze does his publicity pose for the program *Surprize Package*. (Courtesy of Boston Public Library.)

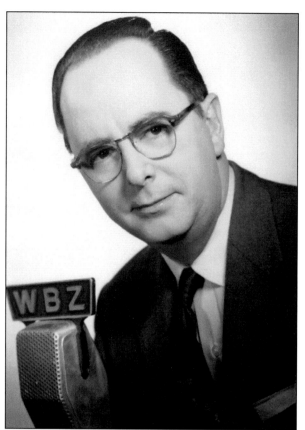

Most people recall Arch MacDonald and Jack Chase for their television careers, but both came from radio. MacDonald started at WPRO in Providence. He came to WBZ in 1936, working as an announcer in addition to covering news and college sports. He spent a decade in radio news before making the transition to WBZ-TV, delivering the station's first newscast in June 1948. MacDonald is shown at the WBZ microphone in this publicity photograph. (Courtesy of WBZ.)

Jack Chase began his Boston radio career in 1948 as a reporter for WCOP. By 1952, he had become the station's news director. He joined WBZ-TV in 1954, and his voice was sometimes heard on WBZ Radio. This undated photograph below was his publicity shot for WBZ-TV. (Author's collection.)

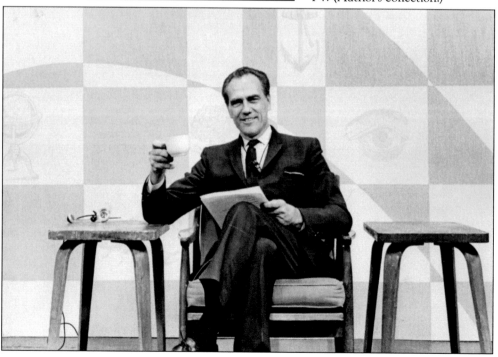

Here is a 1963 photograph of Irving "Bump" Hadley. Having been a major league pitcher for 16 years, upon his retirement, the Lynn native began doing a sports show on WBZ Radio, starting in 1942. (Courtesy of Boston Public Library.)

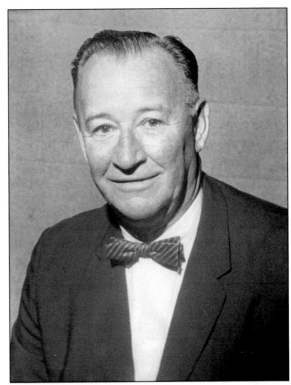

In the early 1940s, the Red Sox and Braves home games remained on WNAC, with Jim Britt doing the play-by-play. Britt was assisted by Tom Hussey and was then joined by Bump Hadley. In 1947, the games were moved to a new station, WHDH. Britt and Hussey moved too and announced the games for both teams until the 1951 season. This photograph of Britt was taken in 1950. (Courtesy of Boston Public Library.)

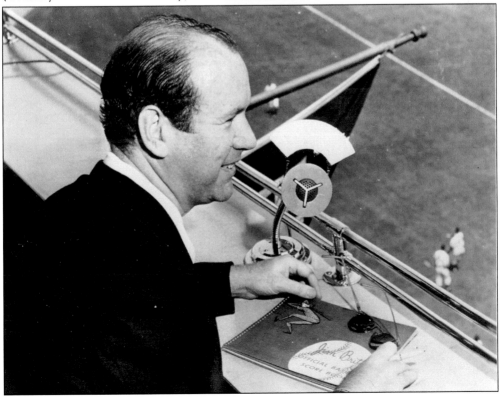

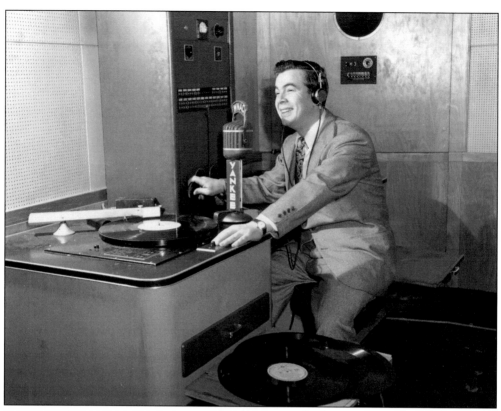

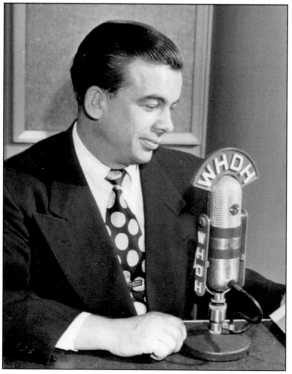

In the era when radio still featured live performers, listeners loved Ray Dorey. He was an announcer and a singer at WBRK in Pittsfield, when, in June 1943, Benny Goodman's orchestra hired him. He toured with them and also made some records; his 1947 recording of "Mam'selle" was his biggest hit. In Boston, Dorey worked for WNAC several times, beginning in 1941. Pictured in the photograph above, Dorey is seen at the Yankee Network microphone. Singers moved around a lot back then, so in 1946, he joined WBZ. By 1949, he was working for WHDH, where he soon hosted the morning show. The 1952 photograph at left is his publicity shot. (Both, courtesy of the Boston Public Library.)

It may never be known who Boston's first black announcer was. Some sources say it was Eddy Petty at WVOM. But others say it was Sebastian "Sabby" Lewis, a talented jazz pianist whose orchestra was heard often on Boston radio. His announcing career began on WBMS in the early 1950s. He played records and also did the announcing for Gretchen Jackson, a popular women's show host. This undated photograph is his standard publicity shot. (Courtesy of Boston Public Library.)

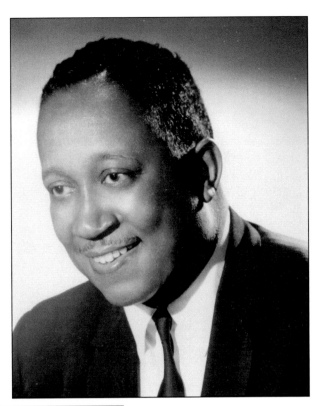

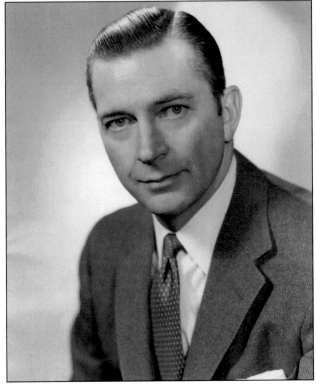

This 1958 publicity photograph shows Arthur "Art" Amadon, the "Serenader." Like Ray Dorey, Amadon began as a vocalist, first on WEEI in the late 1930s and then on WBZ during the 1940s. By the late 1940s, he was reporting the news for WBZ on both radio and television. (Courtesy of Boston Public Library.)

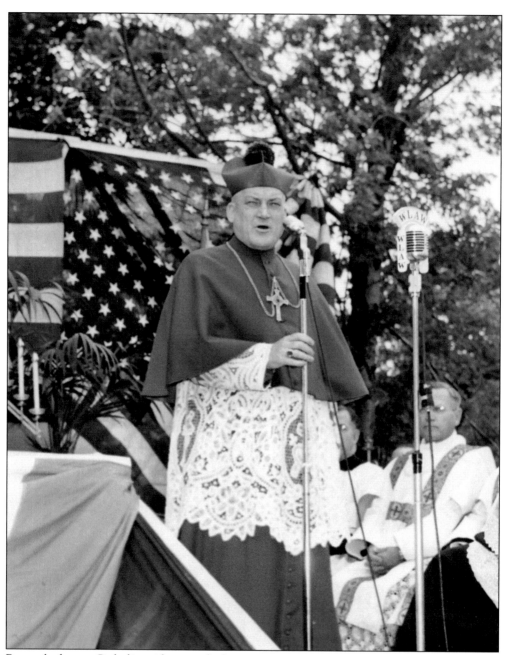

Boston had many Catholic residents, and religious programs were important to them. Fr. Michael J. Ahern's *Catholic Truth Hour* began on WNAC in the late 1920s, and other local priests and bishops also spoke on other stations. Even Cardinal William O'Connell gave a number of talks that local stations carried. When Cardinal O'Connell died in 1943, the installation of the new archbishop of Boston, Richard J. Cushing, was covered by Boston radio. Archbishop Cushing would be heard on the air on many occasions, and during the late 1950s, he said the rosary daily over WEZE. In this August 1948 photograph, Archbishop Cushing is speaking at an outdoor mass, over station WLAW. (Courtesy of Boston Public Library.)

Announcer Sherm Feller and his wife, vocalist Judy Valentine, are seen in this 1949 photograph. They met at WLLH in Lowell, married in 1945, and became known on air as "A Feller and His Girl." They moved to Boston radio in the late 1940s and were on WCOP, WEEI, and WVDA. Sherm was later known as the Boston Red Sox public address announcer; he also wrote many hit songs. (Author's collection.)

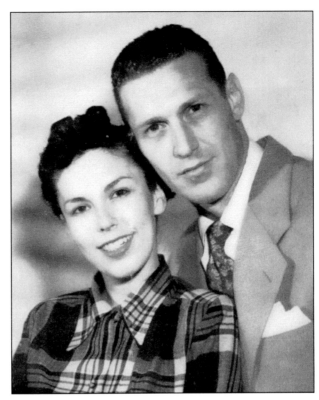

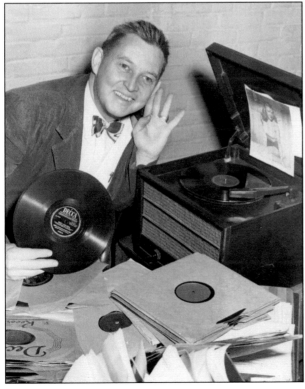

Fred B. Cole was a popular announcer on WBZ and NBC Radio in the late 1930s. His *Carnival of Music* program debuted on WHDH in 1946; he worked there for 21 years. Cole is pictured in 1948 in the WHDH studio. (Courtesy of Boston Public Library.)

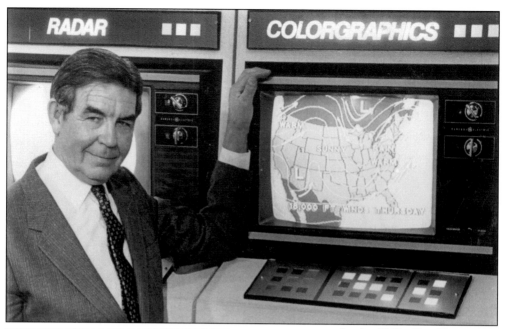

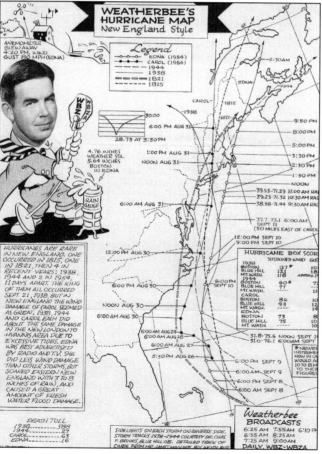

In the 1940s, Don Kent established himself as a reliable weather forecaster. As a youth, Kent was inspired by WEEI's E. B. Rideout, whom he met in the mid-1920s. Working first at WMEX, he was at Quincy's new station, WJDA, by the late 1940s. Kent joined WBZ Radio in 1951, and he is pictured above in 1955 working on a WBZ-TV forecast. In the 1950s WBZ promotional piece at left, he is using his on-air persona, the "Weatherbee." (Above, courtesy of *Quincy Patriot-Ledger*; left, courtesy of WBZ Radio.)

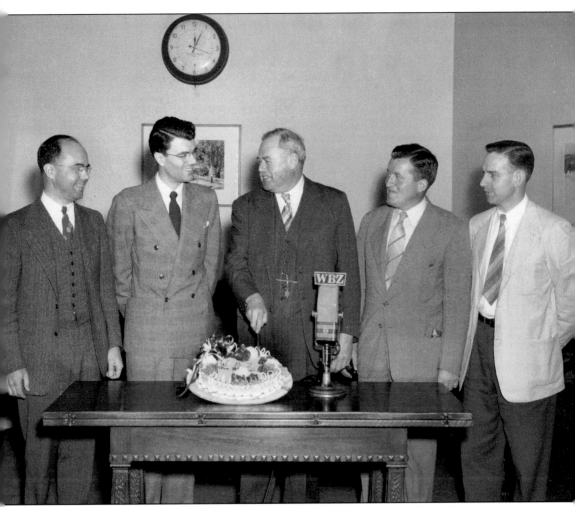

Although FM was still not a major factor in Boston, it had a new proponent, Ralph Lowell, trustee of the Lowell Institute. He put WGBH-FM on the air in October 1951, broadcasting classical music and cultural programs. In 1946, he had founded the Lowell Institute Cooperative Broadcasting Council to promote educational programs. In this June 1948 photograph, Lowell is celebrating the first anniversary of *Our Weather*, a radio course on meteorology conducted by members of the Massachusetts Institute of Technology (MIT) faculty. Those pictured are, from left to right, Dr. Henry G. Houghton, chairman of MIT's Meteorology Department; Wilmer "Bill" Swartley, general manager of WBZ Radio and television; Lowell; and MIT professors James. M. Austin and Delbar P. Keily. (Courtesy of Boston Public Library.)

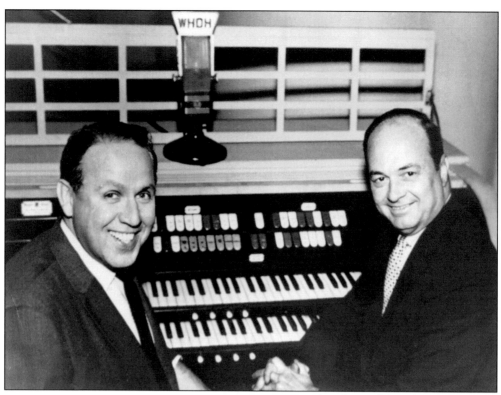

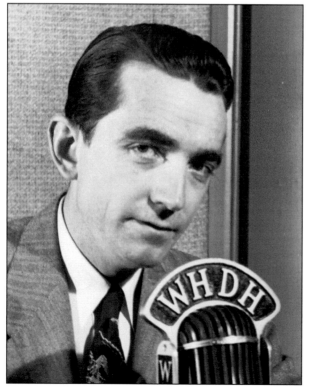

Another well-loved musical duo was Ken and Bill, who were heard on WHDH beginning in 1948. Ken Wilson (right), who played the organ, had been with WHDH since 1931, and Bill Green (left) had played piano on a number of WHDH programs, including the *Bob and Ray Show*. In addition, Bill was a member of a WHDH vocal group, The Park Squares. Ken and Bill's show ran for nearly 20 years. This photograph shows them in 1959. (Courtesy of Boston Public Library.)

Leo Egan came to Boston from Buffalo. He first worked at WNAC in the late 1930s and then transferred to WHDH in 1946. By 1953, he had his own sports show on WBZ, but he returned to WHDH in the early 1960s. Egan is pictured at WHDH in 1948. (Courtesy of Boston Public Library.)

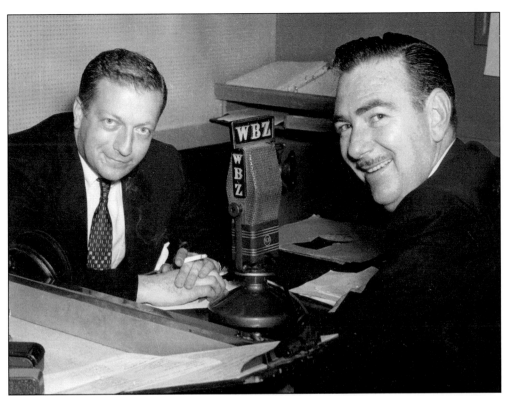

In the 1955 photograph above, Bob Elliott and Ray Goulding are celebrating their new contract with WBZ Radio. It all began when Bob, a WHDH announcer, began bantering with newsman Ray. Their ability to do improvised sketches impressed the management, which gave them their own show. *Matinee with Bob and Ray* debuted on WHDH in 1946. The pair specialized in a satirical view of popular culture, lampooning Hum and Strum, Mary Margaret McBride, and even Arthur Godfrey. They created numerous humorous characters like "Wally Ballou" and "Biff Burns." In the 1951 photograph at right, they are dressed as milkmen to promote a sponsor, H. P. Hood and Sons. (Both, courtesy of the Boston Public Library.)

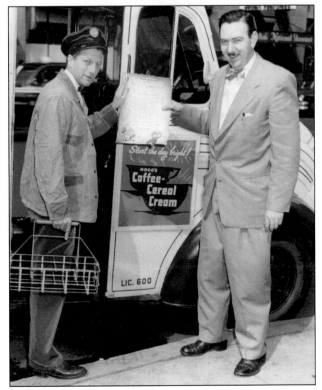

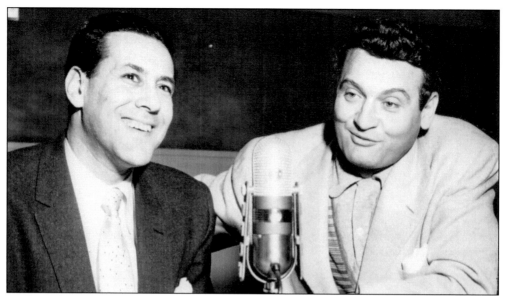

In the early 1950s, disc jockeys were becoming more influential, and Bob Clayton of WHDH was one of the local hit-makers. His *Boston Ballroom* featured the top records and interviews with performers. In this 1953 photograph, Clayton (left) is interviewing pop star Frankie Laine. (Courtesy of Boston Public Library.)

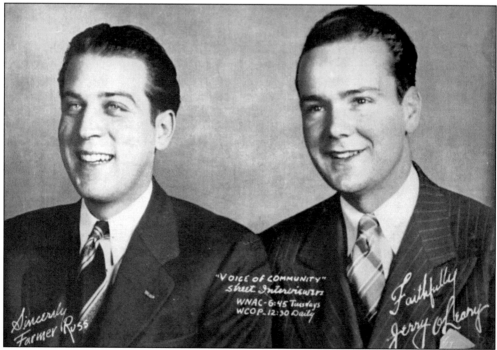

This photograph from the mid-1940s shows Russ Offhaus (left) and Jerry O'Leary. During the 1940s, Offhaus made his audience smile as "Farmer Russ" on WCOP, and later on WVOM. O'Leary was a veteran announcer who had been on WORL, WNAC, and WHDH. People knew him for his man-on-the-street interviews, and O'Leary was also the host of several quiz shows. (Courtesy of New England Country Music Historical Society.)

Dick Tucker was hired by WBZ program director Gordon Swan around 1949. Tucker was not only a talented announcer but also a skilled interviewer. On WBZ-TV, he became what the press called a video disk jockey, playing hit songs and interviewing interesting guests. This photograph, probably from 1952, shows him with fellow WBZ-TV personality Dick Estes. (Author's collection.)

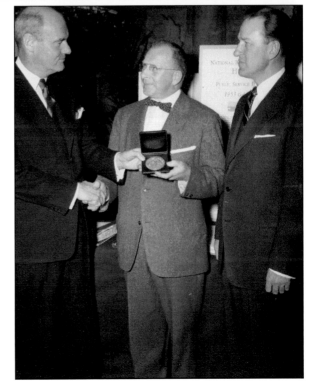

This 1954 photograph shows Gordon Swan, who frequently advocated for fire prevention and safety. Here he is receiving a gold medal for public service from J. Victor Herd (left), the vice president of the National Board of Fire Underwriters (NBFU), and Lewis A. Vincent (right), the general manager of the NBFU. (Courtesy of Boston Public Library.)

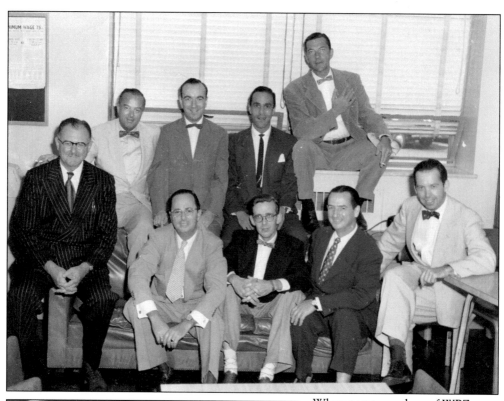

When some members of WBZ Radio and Television posed for this photograph, it was probably 1949, since the headline about the minimum wage being raised to 75¢ an hour is seen at upper left. Those pictured are, from left to right, (first row) Dick Tucker, Streeter Stuart, Dick McKay, Arch MacDonald, and Robert Rissling; (second row) Art Amadon, Carl de Suze, Lindy Miller, and Colton "Chick" Morris. (Author's collection.)

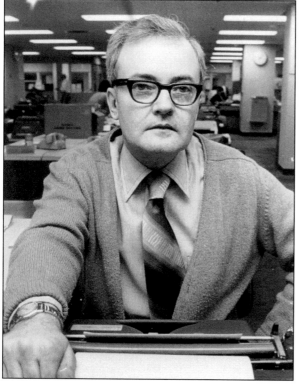

This photograph from the early 1960s shows veteran journalist Bill Buchanan. An award-winning reporter, he also loved music and began hosting a big band jazz show on WVDA Radio in 1953. During the 1950s, he was also heard on WILD and WBZ. (Courtesy of *Boston Globe*.)

This photograph shows veteran WBZ newsman Streeter Stuart. A former professor of modern languages, he first worked at shortwave station WBOS in 1940 and also worked on WBZ's early FM station, W1XK. He went on to a long career on WBZ as a news reporter. (Courtesy of Boston Public Library.)

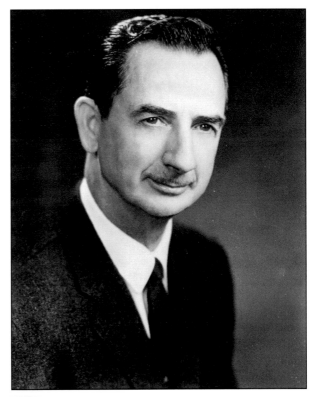

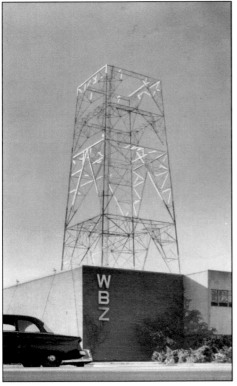

Hurricane Carol arrived in late August 1954, with torrential rains and damaging winds. A television crew that was filming outside WBZ's Soldiers Field Road studios noticed the television tower was swaying; it suddenly gave way, and a large segment struck the WBZ building. Amazingly, no one inside was seriously injured, although the building sustained damage and a number of cars were flattened. WBZ Radio was only off the air for three minutes; WBZ-TV was back on the air the next day, using a standby antenna. This photograph shows how only 200 feet of the tower remained. (Courtesy of Boston Public Library.)

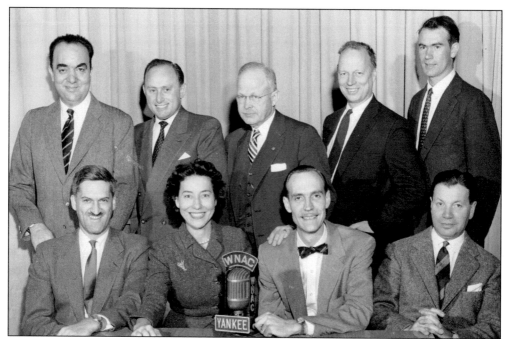

During the 1940s and 1950s, Bill Hahn was one of WNAC's best-known announcers. In the late 1940s, he had a highly rated morning show called *Breakfast with Bill*. In the 1950s, he and Duncan MacDonald hosted and coproduced the *Yankee Home and Food Show*. This 1956 photograph shows them posing with consuls who were giving Christmas greetings from their countries. Pictured in the first row are, from left to right, Jean Fournier of Canada (dean of the Consular Corps), Duncan MacDonald, Bill Hahn, and Girolama Vitelli of Italy. Those pictured in the second row include consuls from Greece, Germany, Lithuania, Denmark, and Ireland. (Courtesy of Boston Public Library.)

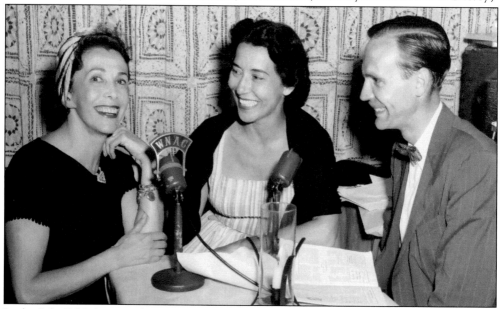

In this July 1956 photograph, MacDonald (center) and Hahn (right) are interviewing actress Lili Darvas at the Falmouth Playhouse. (Courtesy of Duncan MacDonald.)

Four

NEW FORMATS, NEW STATIONS

In the mid-1950s, Top 40 burst onto the scene, and there were dramatic changes in Boston radio. In September 1957, WMEX was sold to Maxwell and Richard Richmond. Within the next few months, it became a Top 40 station and grew in popularity. The Richmond brothers also tried to appeal to older adults by airing a talk show, starring Jerry Williams. The same strategy was used by WBZ, which abandoned NBC network programming in September 1956, using a team of disc jockeys known as the "Live Five." In the 1960s, the station played pop music, but it also had an evening talk show called *Contact* with Bob Kennedy.

Some stations struggled to find the right niche. WBMS ("World's Best Music Station") originally played classical music, but it changed format several times prior to focusing on an African American audience. When WBMS was sold in 1957, the new owners changed the call letters to WILD. While Boston's black community was not as large as in some cities, it was very loyal to the station. Among WILD's most popular disc jockeys was Jimmy "Early" Byrd, who did the morning show in the early to mid-1960s. In the spring of 1967, WILD went to a black Top 40 format. WNAC also struggled, briefly abandoning Middle of the Road (MOR) in 1960 to try Top 40, then going back to MOR. In February 1967, the Yankee Network came to an end, and in mid-March, under the new call letters of WRKO, the station became a tightly playlisted Top 40, a very successful move this time.

The other new thing in Boston radio was the rise of FM. With a 1964 FCC ruling that AM owners could not simply simulcast on their FM stations, new formats emerged, including underground or progressive rock. By 1969, a Boston classical music FM, WBCN (Boston Concert Network), changed to this new format and became a dominant station. Americans were becoming divided over issues like Vietnam, and FM played protest music that AM would not play. FM also played longer versions of songs, where AM Top 40 usually limited songs to fewer than three minutes. There was a payola scandal in 1959–1960 that affected several Boston disc jockeys. And while many older critics and announcers wished rock music would go away, it only became more popular.

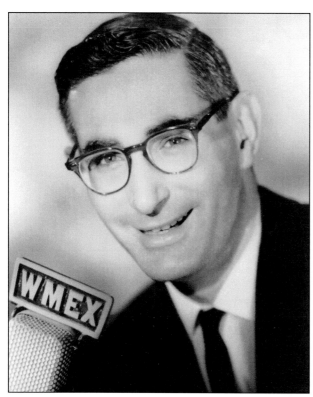

From the late 1950s through the mid-1960s, young people loved WMEX. According to audience surveys, Arnie Ginsburg was still the number one disc jockey in town, and wherever he went, the fans followed, whether it was to Adventure Car Hop or the Surf Ballroom or his many record hops. Here is an undated publicity photograph. (Author's collection.)

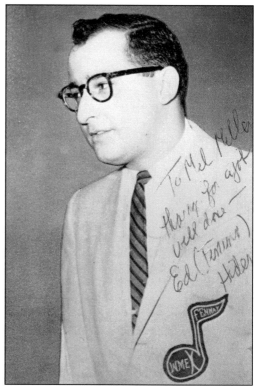

Here is Ed Hider in an early 1960s photograph. He came over from WCOP and became known as "Fenway" during 1961 and 1962. By 1963, he was working for WINS in New York. (Courtesy of Helen Miller.)

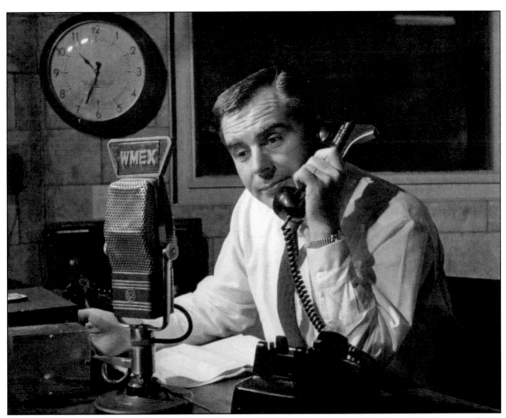

Jerry Williams was king of talk radio in Boston. In fact, many people believed he invented the format. From his first show on WMEX in September 1957, Williams built a reputation for talk radio that was both exciting and thought-provoking. In this undated photograph, Jerry Williams is seen in the WMEX studios. (Courtesy of Steve Elman.)

Another popular talk show, *Contact*, debuted on WBZ in late September 1963. It was hosted by an announcer who jokingly called himself "the other Bob Kennedy"—not to be confused with Robert F. "Bobby" Kennedy. Bob Kennedy handled talk and public affairs for WBZ, and *Contact* later won several awards. In this photograph, probably from 1964, he talks with young Sen. Ted Kennedy. (Courtesy of Bev Kennedy.)

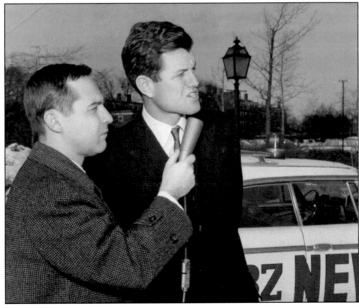

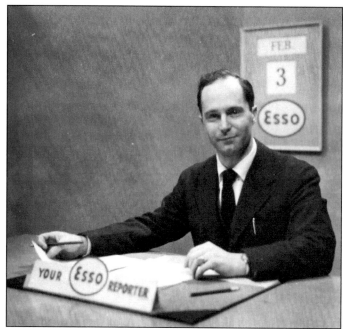

In the 1950s, Victor Best anchored WBZ-TV's *Your Esso Reporter*. When he was fired in 1960, he changed careers. He learned that Northeast Broadcasting School was seeking a director, and he not only got the job—he ended up buying the school in 1962. This photograph shows him during his television days. (Author's collection.)

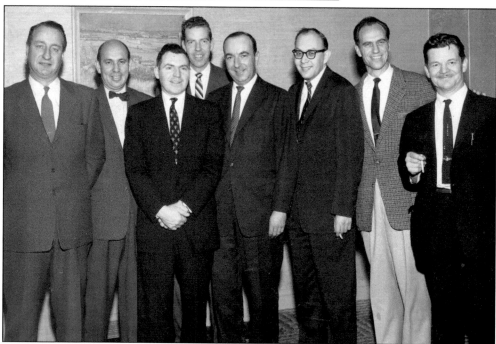

This 1958 photograph shows the Boston officers of the American Federation of Television and Radio Artists (AFTRA) and the Screen Actors Guild (SAG). Those pictured are, from left to right, Art Gardner (WBZ), Bob Segal (New England executive secretary of AFTRA and SAG), Dick Kilbride (freelance actor and SAG president), Ed Kane (WBZ and AFTRA treasurer), Lindy Miller (WBZ and AFTRA president), Norm Nathan (WHDH announcer and AFTRA vice president), Jack Chase (WBZ-TV, AFTRA board member, and vice president of SAG), and Conrad Jameson (freelance actor and vice president of SAG). (Courtesy of Boston Public Library.)

For some disc jockeys, the transition to rock and roll was easy. For others, it was something to be avoided. Joe Smith was among those who handled the transition easily. The Chelsea native played rhythm and blues and rock and roll at WVDA. In 1961, he left radio for the record business, where he rose to president of Warner Brothers Records. The 1959 photograph at right shows him when he worked for WILD. Bill Marlowe, on the other hand, hated rock and roll. At one point, he told a reporter, "I play M-U-S-I-C, not N-O-I-S-E." Marlowe worked for a number of Boston stations in the 1950s and 1960s, including WILD, WBZ, and WNAC. The 1959 photograph below shows him at WILD. (Both, courtesy of Boston Public Library.)

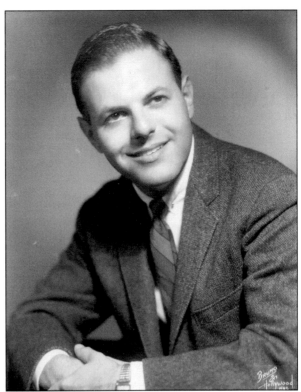

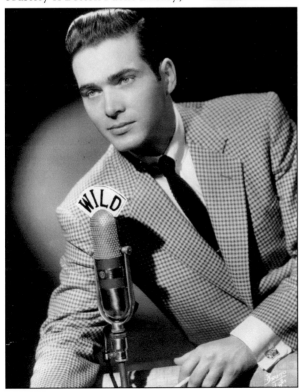

Curtis Edward "Curt" Gowdy won an audition to work with New York Yankees broadcaster Mel Allen in 1949. He came to Boston in 1951. Previously Jim Britt had announced both the Red Sox and Braves home games, but now Gowdy would be the Red Sox announcer, while Britt did the Braves games. Gowdy remained with the Sox until the end of 1965, when he left for NBC Sports. At left is his mid-1960s publicity photograph. Pictured below in 1953, Gowdy (seated at right) is showing James Jeanotte (seated at left) of Concord, New Hampshire, how the broadcasts are done. Behind them are Bob Murphy and Bill Crowley, Gowdy's WHDH play-by-play partners. (Both, courtesy of Boston Public Library.)

Johnny Most began his Boston radio career as sports director of WCOP in late 1953. At that time, Curt Gowdy was calling the Celtics games, and Most was his partner. Most soon became the "Voice of the Celtics." He was seldom objective, always viewing the other teams as unsportsmanlike, with the Celtics always being innocent. Fans loved him and did not mind his cheerleading. This 1966 photograph is his publicity shot. (Courtesy of Boston Public Library.)

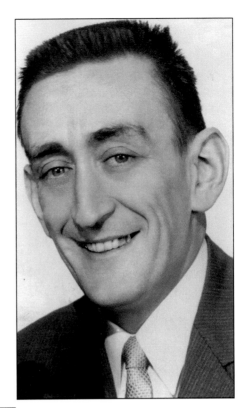

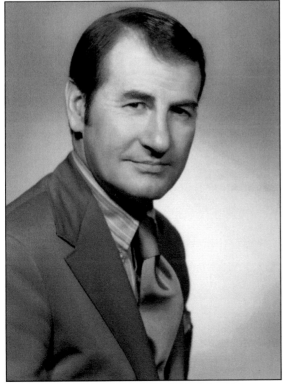

Most people identify Don Gillis with the *Candlepin Bowling* television program, but he worked in radio for years. He joined WHDH in 1951, covering a variety of sports. Gillis later hosted a popular roundtable sports talk show, *Voice of Sports*, with a panel of sportswriters. This undated image is his publicity photograph. (Courtesy of Boston Public Library.)

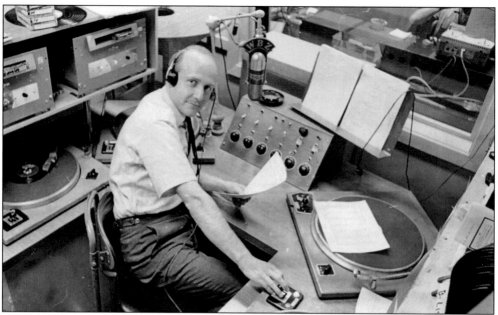

Bruce Bradley joined WBZ in 1960, handling the evening shift. "Juicy Brucie" had a quirky sense of humor and quickly became popular. He was often the master of ceremonies for concerts, which included the Beatles at Suffolk Downs in 1966. Bradley also did live shows at Paragon Park in the Sundeck Studio. He remained with WBZ until June 1968, when he left for a job in New York City. This 1964 photograph shows him in the WBZ studios. (Courtesy of Boston Public Library.)

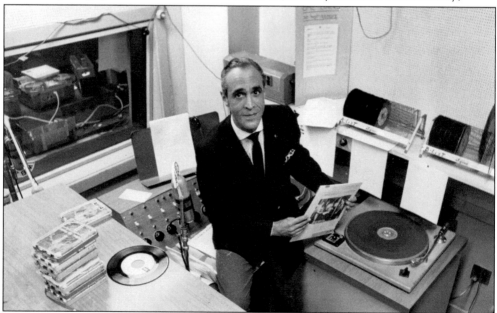

If Bruce Bradley was beloved by teenagers, WBZ morning show host Carl de Suze was a favorite of adults. He was able to adapt to the changes in the music. When he started there in 1942, it was jazz and big band, which later changed to Elvis and the Beatles. Carl de Suze continued telling interesting stories of places he went and people he met. This 1964 photograph was taken in the WBZ studios. (Courtesy of Boston Public Library.)

Dick Summer attracted thousands of college students and insomniacs to the overnight shift on WBZ. His *Night Light* show had a cast of mythical characters like "Irving the Venus Fly Trap." Summer also liked poetry and songs with emotional lyrics. After leaving WBZ in June 1968, he returned to Boston in the spring of 1969 to become program director of WMEX. This undated photograph shows Summer at the WBZ microphone. (Courtesy of WBZ Radio.)

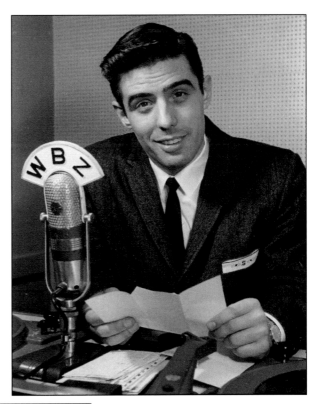

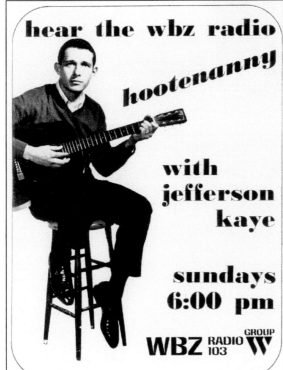

In addition to being a WBZ disc jockey, Jefferson Kaye was known for his Sunday night *Hootenanny* program in the early 1960s. He played the best of traditional folk and up-and-coming artists, such as Tom Rush. Kaye left WBZ for WKBW in Buffalo in March 1966. This is the promotional item for *Hootenanny*. (Courtesy of WBZ Radio.)

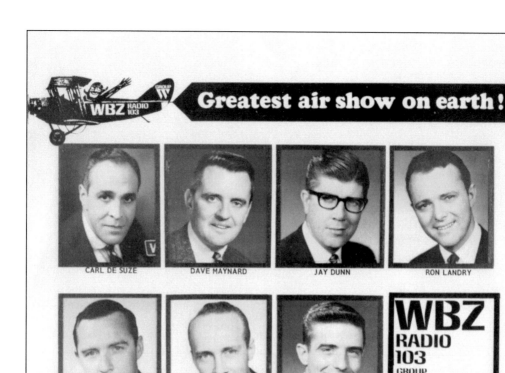

Greatest air show on earth!

WBZ RADIO 103 GROUP W

CARL DE SUZE DAVE MAYNARD JAY DUNN RON LANDRY

BOB KENNEDY BRUCE BRADLEY DICK SUMMER

WBZ RADIO 103 GROUP W

WESTINGHOUSE BROADCASTING COMPANY

WMEX 1967 FUN 100 FROM THE POWER 30 SURVEYS

HOME OF THE "GOOD GUYS" 1510

1. The Letter	The Boxtops	
2. Light My Fire	The Doors	
3. Can't Take My Eyes Off You	Frankie Valli	
4. Ode To Billie Joe	Bobbie Gentry	
5. To Sir With Love	Lulu	
6. Happy Together	The Turtles	
7. Windy	Association	
8. I'm A Believer	The Monkees	
9. Groovin'	The Young Rascals	
10. Respect	Aretha Franklin	
11. Georgy Girl	The Seekers	
12. I Think We're Alone Now	Tommy James & Shondells	
13. Something Stupid	Frank & Nancy Sinatra	
14. Soul Man	Sam and Dave	
15. Come Back When You Grew Up	Bobby Vee	
16. Sweet Soul Music	Arthur Conley	
17. Ruby Tuesday	The Rolling Stones	
18. Kind Of A Drag	The Buckinghams	
19. A Little Bit Of Soul	The Music Explosion	
20. I Got Rhythm	The Happenings	
21. Reflections	The Supremes	
22. Somebody To Love	The Jefferson Airplane	
23. The Happening	The Supremes	
24. She'd Rather Be With Me	The Turtles	
25. Come On Down To My Boat	Every Mother's Son	
26. I Was Made To Love Her	Stevie Wonder	
27. Incense & Peppermints	Strawberry Alarm Clock	
28. Then You Can Tell Me Goodbye	The Casinos	
29. Apples Peaches Pumpkin Pie	Jay & The Techniques	
30. Little Bit Me, Little Bit You	Monkees	
31. Rain, Park & Other Things	The Cowsills	
32. Mercy Mercy Mercy	The Buckinghams	
33. Never My Love	The Association	
34. It Must Be Him	Vicki Carr	
35. There's A Kind Of A Hush	Herman's Hermits	
36. We Ain't Got Nothing Yet	Blues Magoos	
37. Dedicated To The One I Love	Mama's & Papa's	
38. Don't You Care	The Buckinghams	
39. This Is My Song	Petula Clark	
40. Love Is Here & Now You're Gone	The Supremes	
41. Sock It To Me	Mitch Ryder	
42. Release Me	Engelbert Humperdinck	
43. All I Need Is Love	The Beatles	
44. Expressway To Your Heart	The Soul Survivors	
45. Penny Lane	The Beatles	
46. Please Love Me Forever	Bobby Vinton	
47. Jimmy Mack	Martha & The Vandellas	
48. A Whiter Shade Of Pale	Procol Harum	
49. Baby I Love You	Aretha Franklin	
50. Snoopy vs. The Red Baron	The Royal Guardsman	
51. How Can I Be Sure	The Young Rascals	
52. For What It's Worth	Buffalo Springfield	
53. Tell It Like It Is	Aaron Neville	
54. My Cup Runneth Over	Mr. Ed Ames	
55. Let's Live For Today	The Grass Roots	
56. Silence Is Golden	The Tremeloes	
57. Up, Up And Away	The Fifth Dimension	
58. Carrie Ann	The Hollies	
59. Your Precious Love	Marvin and Tammi	
60. White Rabbit	Jefferson Airplane	
61. Brown Eyed Girl	Van Morrison	
62. Pleasant Valley Sunday	The Monkees	
63. Gimme Little Sign	Brenton Wood	
64. Green Green Grass Of Home	Tom Jones	
65. The Beat Goes On	Sonny and Cher	
66. Higher And Higher	Jackie Wilson	
67. 98.6	Keith	
68. Funky Broadway	Wilson Pickett	
69. Society's Child	Janis Ian	
70. San Francisco Flowers	Scott McKenzie	
71. Baby I Need Your Lovin'	Johnny Rivers	
72. Alfie	Dionne Warwick	
73. You're My Everything	The Temptations	
74. I Second That Motion	The Miracles	
75. Close Your Eyes	Peaches and Herb	
76. San Francisco Nights	The Animals	
77. Girl You'll Be A Woman Soon	Neil Diamond	
78. All I Need	The Temptations	
79. On A Carousel	The Hollies	
80. Western Union	The Five Americans	

For AM Top 40 stations, the 1960s and early 1970s were the last years in which music alone would be enough. Although some stations were already expanding their news or adding talk shows, it was still the era of the disc jockey. In this item, probably from 1966, WBZ promoted its announcers and slogan, "The Greatest Air Show on Earth." (Author's collection.)

In the 1960s, many Top 40 stations were still putting out weekly hit music surveys, and many baby boomers collected them. This one is from WMEX in 1967. (Author's collection.)

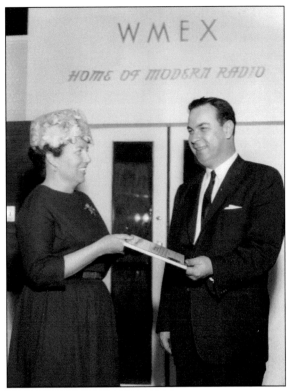

Maxwell and Richard Richmond purchased WMEX in the summer of 1957. "Mac" Richmond was a former advertising executive who had owned WPGC in Washington, D.C., since 1954. A controversial figure in Boston radio, he frequently fired staff and was known as a micromanager, but his work ethic turned WMEX into a dominant force in Boston Top 40. He died suddenly at age 57 in late October 1971. In the undated photograph at right, Richmond is receiving a public service award in front of the new Broadcast House on Broadway, which was where the station moved around 1967. In the June 1973 photograph below, Richard J. Richmond is seen with Ernest Borgnine and Barbara Kelsey. (Both, author's collection.)

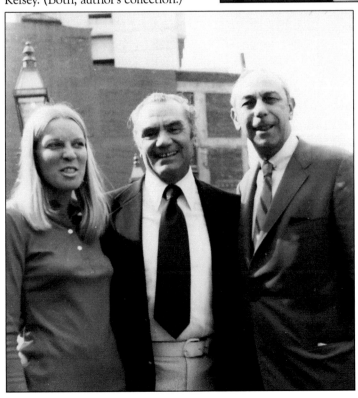

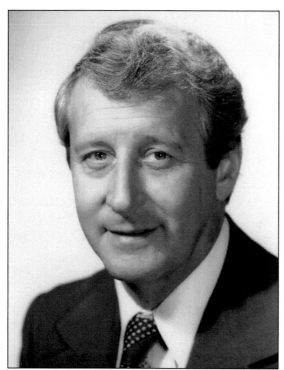

In Top 40's heyday, local disc jockeys promoted their station in a number of ways. Mel Miller, Stan Richards, Arnie Ginsburg, and others did record hops or appeared anywhere teenagers gathered. This 1982 photograph shows Miller, who was the program director at WMEX during the early 1960s. Miller was also the host of the *Gold Platter Show*. (Courtesy of Helen Miller.)

In this photograph, probably from 1959, Stan Richards is receiving an award from a local broadcasting school. He was a disc jockey for WCOP, WORL, and WILD and also hosted WBZ-TV's *Totem Pole Matinee*. (Author's collection.)

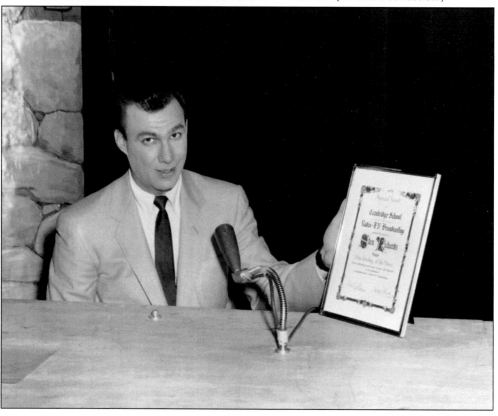

Tom Russell worked with Ray Dorey at WBRK in Western Massachusetts and then spent some time in New York. He returned to Boston in 1955, where he worked with Carl Moore on WEEI's *Beantown Varieties*—one of the few radio shows that still had live music. He later hosted a talk show called *At Your Service*. This is the postcard that Russell sent out to fans. (Author's collection.)

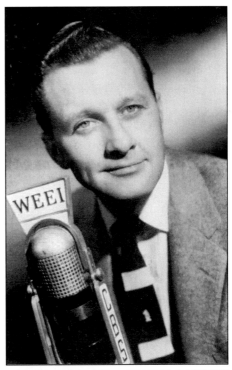

One classical station that was doing well was WCRB, which got a power increase in 1957. Pictured below are Richard Kaye (right) and Charles Munch of the Boston Symphony Orchestra. Kaye was WCRB's popular announcer and part owner of the Waltham station. He was instrumental in creating WCRB-FM. (Courtesy of Boston Public Library.)

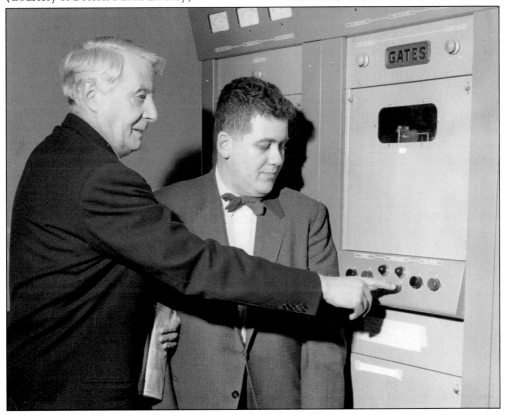

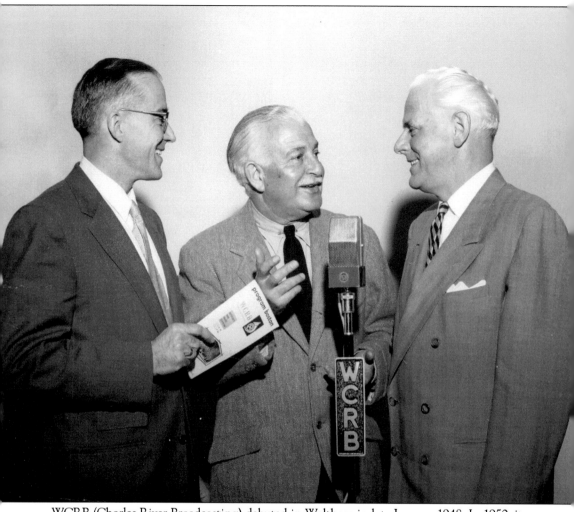

WCRB (Charles River Broadcasting) debuted in Waltham in late January 1948. In 1950, it was purchased by Theodore "Ted" Jones, who operated the station with his wife, Nathalie. Jones loved WCRB's classical music format so much that he placed his majority stock into a trust that he hoped would preserve the station's format for the next 100 years. In 1954, Jones purchased WHAV-FM in Haverhill. At a time when FM's success was still uncertain, Jones and his staff, which included Richard Kaye and Dave MacNeill, correctly believed an FM stereo signal would be of great benefit to WCRB's listeners. Pictured at the March 1958 opening of a new Boston studio at the Sheraton-Plaza Hotel penthouse are, from left to right, Ted Jones, president of WCRB; conductor Arthur Fiedler; and H. deFine Nyboe, the general manager of the Sheraton-Plaza Hotel. (Courtesy of Boston Public Library.)

Charles Laquidara was hired at WBCN in 1969. By 1972, he became the morning host on his *Big Mattress* show. The era when WBCN changed to progressive rock was a golden age for the format. Announcers were now allowed the freedom to select the music and express political views. Laquidara spoke out against corporate greed, even if it meant being critical of a sponsor. This undated photograph is a promotional photograph. (Courtesy of Cha-Chi Loprete.)

WBCN
104.1FM
Charles Laquidara

WBCN
104.1FM
Cha-Chi

Larry "Cha-Chi" Loprete began his radio career in 1981, answering the phone at WBCN. He kept working his way up until he became the station's promotional director. After a long career with WBCN, he joined classic rock station WZLX. He is also an expert on all things Beatles. This WBCN promotional photograph is from the early 1980s. (Courtesy of Cha-Chi Loprete.)

81

Carter Alan

Carter Alan got his start in college radio at MIT's WMBR (Walker Memorial Basement Radio). By 1979, he was also on air part-time at WBCN, where he would soon become a full-time disc jockey. Thanks to him, WBCN began playing the Irish band U2. Alan later wrote two books about the band. This is his WBCN publicity photograph, probably from the early 1980s. (Courtesy of Cha-Chi Loprete.)

In the turbulent 1960s, Sam Kopper played folk and blues for his college station (WAER at Syracuse University). He then became the first rock program director at WBCN and hosted a morning show. After Kopper left WBCN, he started a successful mobile-studio business in 1974, producing live concerts for radio stations. In this 2009 photograph, Kopper is shown at a reunion at the Paradise Rock Club. (Courtesy of Sam Kopper.)

Bradley Jay first came to WBCN around 1982, having done college radio at the University of New Hampshire. He started with a night shift and soon became the station's public affairs director. By the early 1990s, he was on the 7:00 p.m. to 12:00 a.m. shift, doing an edgy—critics said, "raunchy"—show, where he not only played music but also took calls from listeners. He gradually transitioned into being a talk show host. Here is his WBCN promotional photograph. (Courtesy of Cha-Chi Loprete.)

When WBCN left the air in August 2009, Jay's was the last voice the listeners heard. He subsequently was hired by WBZ to produce the *Dan Rea* show. In 2010, he was given his own Sunday night talk show. This photograph shows Jay at WBZ. (Courtesy of WBZ Radio.)

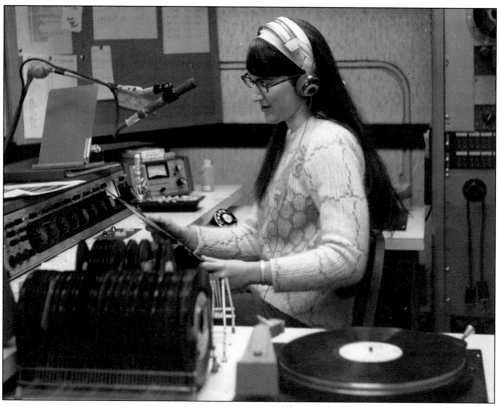

College radio has been the starting point for numerous radio personalities, including the author of this book. Donna Halper debuted in 1968 at Northeastern University's WNEU (known today as WRBB), where she was their first female disc jockey. Her radio career took her to WCAS in Cambridge, WMMS-FM in Cleveland, and stations in New York, Washington, D.C., and Boston. She is a professor and a media historian. This October 1968 photograph shows Halper in the old WNEU studios. (Author's collection.)

Norm Thibeault, another Northeastern alum, also benefited from college radio. Like Halper, he worked at WNEU and then WRBB in the late 1960s. His career took him to New Hampshire and Rhode Island, but since 1998, he has worked at WODS (Oldies 103.3) in Boston and also WBMX. (Courtesy of Norm Thibeault.)

Ned Martin was one of the most eloquent Red Sox announcers, capable of quoting Shakespeare yet able to intricately describe the ins and outs of baseball strategy. Martin came to Boston in 1961. Working with the well-known Curt Gowdy, he quickly became popular with fans. During a career that lasted more than 30 years, he broadcast both baseball and football games. This photograph is from 1970. (Courtesy of Boston Public Library.)

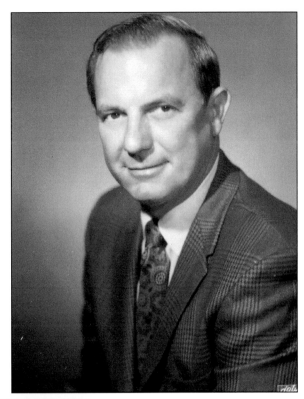

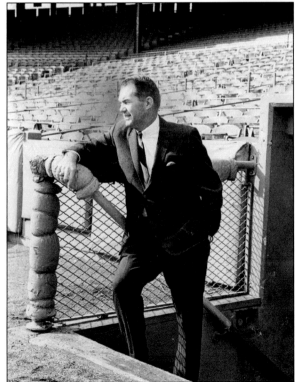

When Curt Gowdy left for NBC, he was replaced by Ken Coleman, who had broadcast Cleveland Indians games for nearly a decade. Coleman and Ned Martin made a good team, calling the games on both radio and television. Coleman left in 1975 for a job in Cincinnati but returned to Red Sox baseball in 1979. This photograph is from 1966. (Courtesy of Boston Public Library.)

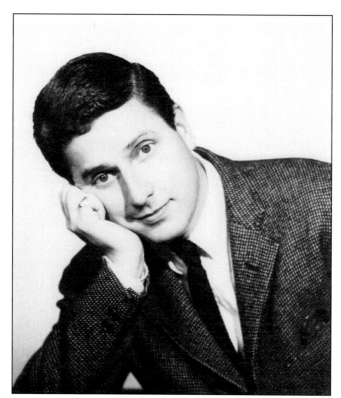

WHDH was known for great air personalities like Bob Clayton and Fred B. Cole, and in 1957, a new personality debuted. Jess Cain made listeners feel they were listening to a trusted friend, even if he was doing a commercial. He was also skilled at creating voices, doing song parodies, and making his audience smile. He was even a talented vocalist. Fans still recall his tribute to Carl Yastzemski, "The Yaz Song." This is a 1969 publicity photograph. (Courtesy of Boston Public Library.)

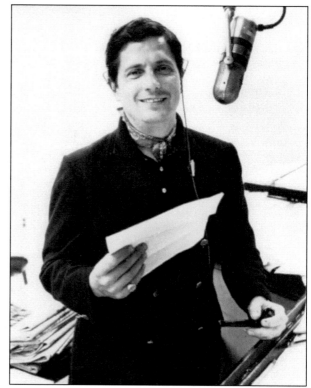

While Cain also appeared in local theater, he loved being on the air. This photograph shows him at the microphone, where he always did an energetic program, assisted by his engineer "Pudge" Flynn. (Courtesy of the Cain family.)

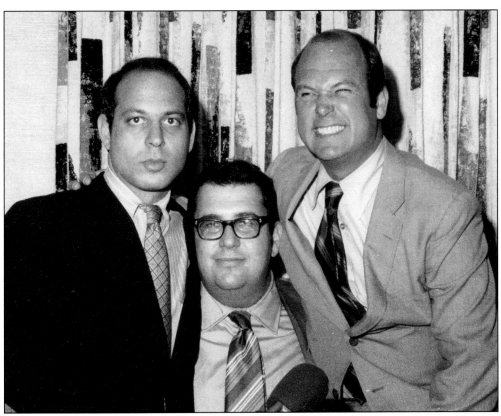

In the late 1960s, more AM stations began broadcasting sports talk. In 1969, Eddie Andelman, Jim McCarthy, and Mark Witkin debuted *Sports Huddle* on WUNR (formerly WVOM), and by 1970, they had been hired by WBZ. The show moved to WEEI in 1971, and Andelman went on to a long and successful career in Boston radio as an opinionated sports talk host. The rare 1970 photograph above shows Andelman in the middle, surrounded by Witkin on the left and McCarthy on the right. After many years at WEEI, Eddie Andelman (right) can now be heard on WTKK-FM. (Above, courtesy of Boston Public Library; right, courtesy of WTKK Radio.)

With his vast knowledge of jazz and wry sense of humor, Norm Nathan was one of Boston's most respected announcers. Fans have fond memories of his *Sounds in the Night*, which was heard late at night on WHDH from the 1950s to the early 1970s. He later worked at WBZ, where once again his warmth and wit pleased fans of all ages. This photograph was taken in 1969. (Courtesy of Boston Public Library.)

Paul Benzaquin began his career as a journalist, and in 1959, he wrote a bestselling book about Boston's Cocoanut Grove fire. He joined WEEI in September 1960 and began doing talk radio there in 1962. He left Boston briefly in 1969 but came back to WEEI in 1971. He joined WBZ in 1976. Here is a WBZ promotional poster from that time. (Courtesy of WBZ Radio.)

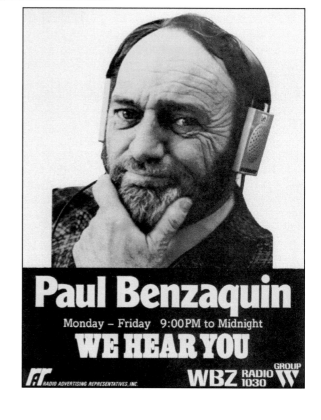

Paul Benzaquin
Monday – Friday 9:00 PM to Midnight
WE HEAR YOU
RADIO ADVERTISING REPRESENTATIVES, INC.
WBZ RADIO 1030 GROUP W

Larry Glick was a Boston institution. The "Commander" came to Boston in 1965 to do the night shift at WMEX; he entertained fans for nearly three decades. Glick was a humorist who enjoyed bantering with his regular callers as well as turning a satirical gaze on popular culture. His fans were "Glickniks," and callers could win T-shirts from the mythical Glick University. This c. 1965 photograph shows him in his younger days. (Courtesy of Boston Public Library.)

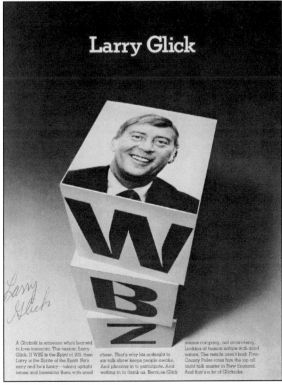

Glick joined WBZ in 1968 and remained there until 1987. He was also a trained hypnotist who used hypnosis to help people quit smoking. Here is a mid-1970s promotional item. (Courtesy of WBZ Radio.)

After briefly moving away from Top 40, WRKO moved back to it, hiring several experienced disc jockeys to redirect the station. One of them was Harry Nelson. He joined WRKO in late 1973, doing the afternoon shift, and retained this time slot through 1978, when he was named program director. In this 1975 photograph taken at the New England Dragway are, from left to right, Top 40 legend Dale Dorman, fellow WRKO disc jockey Jack O'Brien, Miss New England Dragway, and Nelson. (Courtesy of Harry Nelson.)

This is a photograph of well-respected Boston announcer J. J. Wright, who was also one of the few African Americans in Top 40 in the 1970s. Wright joined WRKO in October 1973, remaining there until early 1978. His career took him to WBOS (then Disco 93) and ultimately to a long sojourn at Kiss 108. (Courtesy of J. J. Wright.)

Larry Justice had a long career in Boston radio, ruling over WMEX's *Halls of Justice* beginning in 1965. He joined WBZ in May 1969 and went to WHDH in 1975. He later owned WCIB, a radio station on Cape Cod. Pictured is a promotional item for potential advertisers. (Courtesy of WBZ Radio.)

Larry Justice

New England prefers him 1 to 5. That's after noon and a tricky time for most stations. (It seems you have to lose the men to keep the women.) But Larry eases ours from morning to night with pure aplomb—and that's pure Justice. He does it with music, for the ladies to cook by. And talk. Sporting sports for the men. He even starts keeping track of the traffic long before the rush hour (and other stations), just to make sure the soufflés aren't spoiled by the jams. And with Larry not being blind to any of his audience it pays off: The "Halls of Justice" stay full. 1 to 5.

Joe Green

BZ Copter

JOE GREEN
TRAFFIC REPORTER

WBZ BOSTON RADIO GROUP 1030 W

Stations had been offering traffic reports since 1922, but beginning with WEEI's Bruce Talford in 1961, Boston stations began using helicopters to get a better view; WBZ called theirs the "BZ Copter." Joe Green was not only known for traffic reports—he also saved a life in May 1976 when he rescued a man whose kayak had capsized. This is a promotional postcard. (Author's collection.)

Radio news anchor Gary LaPierre (left) came to WBZ in September 1964, and his first assignment was reporting on the arrival of the Beatles. He later moved up to news anchor. In this photograph, he poses with John Henning (center), a veteran television newsman who joined WBZ-TV in 1982, and Don Kent, a member of WBZ Radio since 1951 who later moved to television. In the early 1980s, the three were doing a noon television newscast. (Courtesy of WBZ Radio.)

This is a promotional postcard for radio talk show host Lovell Dyett, who joined WBZ in 1972 as a weekend announcer. He had previously hosted public affairs programs for Channel 7 and had been an announcer on WILD Radio. In the early 1970s, he began hosting public affairs programs on WBZ-TV. (Courtesy of WBZ Radio.)

While most announcers wanted to work in Boston, some were happy working at suburban stations. One such station with contented announcers was WJDA, which was founded in Quincy by James Asher in 1947. WJDA emphasized local news and broadcast local performers when radio still had live talent. Jay Asher, the son of James Asher and the current owner of the station, is pictured at right in 1997. Sadly, in 2006, WJDA was sold, and ceased being a local station. In WJDA's heyday, Herb Fontaine was the news director, with a career that spanned 30 years. He was a much-loved personality and was known by almost everyone in the community. He is pictured below in 1990 in one of the WJDA studios. (Both, courtesy of *Quincy Patriot-Ledger*.)

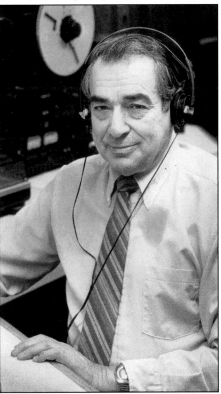

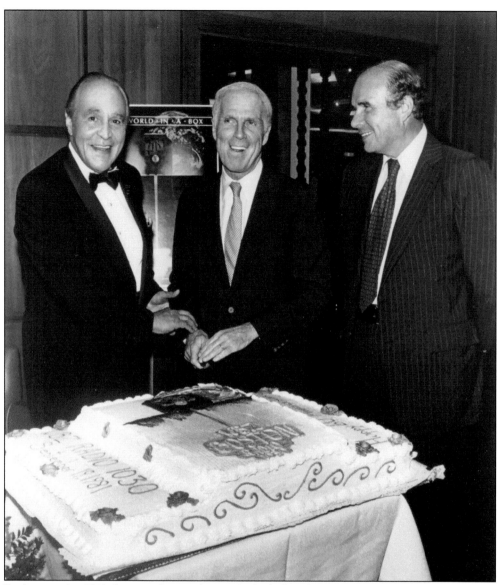

By the time this 1981 photograph was taken, WBZ had a long list of accomplishments. While parent company Westinghouse had divested itself of sister station WBZA in 1962, WBZ was financially healthy and had excellent ratings. There had been one big change in programming—veteran morning host Carl de Suze had been moved to the midday shift, and Dave Maynard now hosted the morning show. The station was also gradually moving away from music and toward more news and information. At this point, the format was full service, and music was secondary to the station's news, sports, weather, and talk shows. At night, WBZ's powerful signal could be heard in 38 states. Preparing to enjoy some 60th-anniversary cake is Carl de Suze, along with Boston mayor Kevin White and WBZ general manager A. B. "Bill" Hartman. (Courtesy of WBZ Radio.)

Five

THE INTERNET AGE

In 1981, President Reagan and the FCC proceeded with deregulation of broadcasting. Gradually, requirements about how much news or public service a station had to offer were eased, and by the decade's end, the Fairness Doctrine, a controversial rule that mandated stations to present both sides of issues, was gone. Owners were also allowed to own more stations. By the time the Telecommunications Act was signed by President Clinton in 1996, many stations were being bought and sold, as bigger stations were buying up smaller ones. In Boston, some stations went dark, some changed frequency, and a handful of large conglomerates soon owned a majority of the stations in town. One venerable name that disappeared was Westinghouse Broadcasting, which ceased to exist in 1997. When Westinghouse and CBS merged in 1996, the CBS name survived, and the Westinghouse name did not.

Meanwhile, music was just about gone on AM, as it was dominated by talk. With the demise of the Fairness Doctrine, opinionated (critics claimed "one-sided") talk shows proliferated. Another format that gained strength was sports talk, giving fans a chance to hear the games and then express their opinions. In Boston, Sports Radio 850 WEEI was born in 1994. WEEI had been at 590, and WHDH has been at 850. But WEEI's new owners wanted a better signal, so in August 1994, WHDH ceased to exist, and WEEI, the new sports talk station, was on the 850 frequency.

On FM, similar events occurred, which included stations changing format. Once a Top 40, WVBF became the country station WCLB (Boston's Country Club) in February 1992, and in June 1995, the call letters were changed again to WKLB. A dramatic event occurred in 2009 when CBS, which owned heritage FM rock station WBCN, closed it down and gave the 104.1 frequency to the former Mix 98.5. Some of the WBCN staff members migrated to classic rocker WZLX. As for the 98.5 frequency, it became a new sports talk station, the Sports Hub, a rival to WEEI-AM. Nearly every station had a Web site, many had blogs, podcasts were popular, and yet radio was still going strong, confounding those who had predicted its demise.

John H. Garabedian began his Top 40 career when he was a teenager, using the name Johnny Gardner. He later worked for a number of stations. He put WGTR in Natick on the air in October 1969. In Boston in about 1970, he was program director at WMEX. And later he was instrumental in starting V-66, a 24-hour video music station. Garabedian also worked at other Boston stations, including WXKS (Kiss 108) and WBCN, and syndicated *Open House Party*, an all-request dance music show. This 1990 photograph, taken at a party for pop star Mariah Carey, is of several important people from the music industry. John H. Garabedian is on the far left, almost obscured by Lisa Fell, general manager of Kiss 108. Others include, from left to right, Sunny Joe White, program director of Kiss; Mariah Carey; and two veteran record promoters, Jerry Brenner and Carl Strube. (Courtesy of John H. Garabedian.)

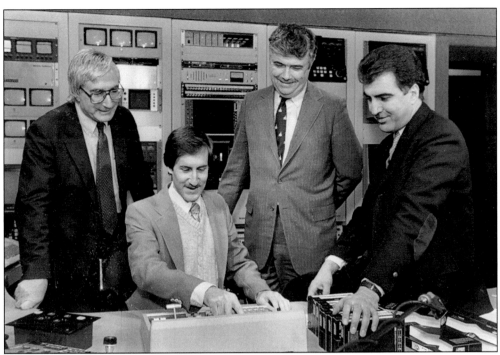

Given the national success of MTV, John H. Garabedian believed a local music video station might work. He and Arnie Ginsburg put V-66, the Beat of Boston, on the air on February 12, 1985. It had many fans, but it was expensive to operate; Garabedian sold it to the Home Shopping Network in late 1986. Checking the studio equipment in 1985 are, from left to right, Arnie Ginsburg, David Beadle, Bill Whelan, and John H. Garabedian. (Courtesy of John H. Garabedian.)

This photograph, probably from 1985, shows Kiss 108 program director Sunny Joe White, who had a very good ear for finding hit records. He is posing with Columbia recording artist Paul Young. (Courtesy of Kiss 108.)

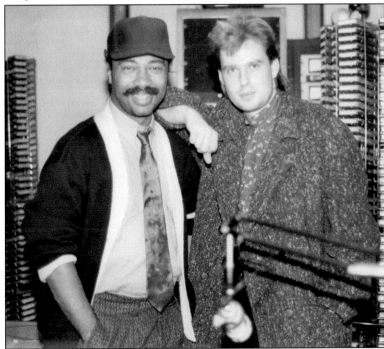

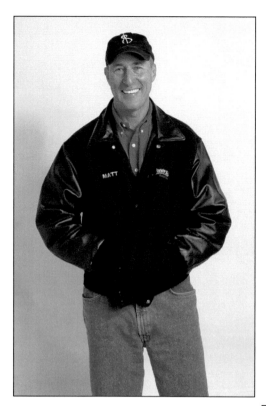

Kiss 108 became a dance-oriented Top 40 station in 1979 and was soon number one with young adults. Matt Siegel joined the station in 1981, after having worked at WBCN. Since then, the *Matty in the Morning* show has enjoyed nearly 30 years of success. Here is a recent promotional photograph. (Courtesy of Kiss 108.)

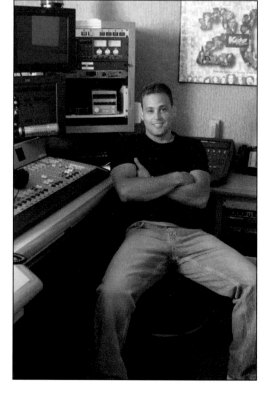

One of the most popular disc jockeys with teenagers is Romeo, whose real name is Neil Paris. He formerly worked at WJMN (JAM'N), and his on-air persona is a playboy loved by the ladies. Historically, Top 40 disc jockeys have chosen a persona they can act out on the air, and in this case, his show is very popular with teenage girls. This photograph shows Romeo in the studio. (Courtesy of Kiss 108.)

José Massó has been on the air at WBUR-FM 90.9 since 1975. While working as a bilingual teacher, his students suggested that he get into broadcasting because there were few Latin music programs on the air at that time. Massó's groundbreaking program, ¡Con Salsa!, became so successful that in late June 2010, it celebrated its 35th anniversary. In September 2010, he was inducted into the Massachusetts Broadcasters Hall of Fame. (Courtesy of WBUR.)

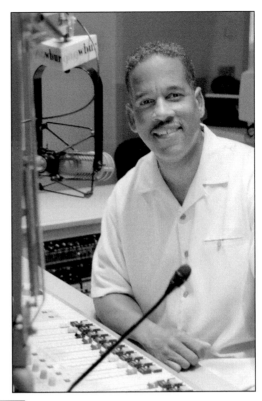

Maurice Lewis has many years of experience as a broadcaster and a journalist. He was a television anchor on Channel 7 from 1972 to 1976 and then worked at WBZ-TV into the early 1980s. He also did talk radio on WBZ around that time. In the late 1980s, he became the public affairs director for WBCN. He has also been a guest on a number of talk shows. (Courtesy of Maurice Lewis.)

Dave Maynard joined WBZ in 1958. He eventually became the morning host, and for 11 years his *Maynard in the Morning* show was number one in the ratings. In addition to radio, he also hosted a television talent show, *Community Auditions*, for 21 years. To commemorate his 25th anniversary on the air, the mayor declared December 1, 1983, as "Dave Maynard Day." Maynard retired from WBZ in 1991. In this August 1978 photograph, Maynard is living on a raft to raise money for Catholic Charities. (Courtesy of WBZ Radio.)

Here is former Top 40 disc jockey Mel Miller at his desk at WRKO, which in 1981 had abandoned music and changed to a news/talk format. Miller was named the program director of what became known as Talkradio 68. (Courtesy of Helen Miller.)

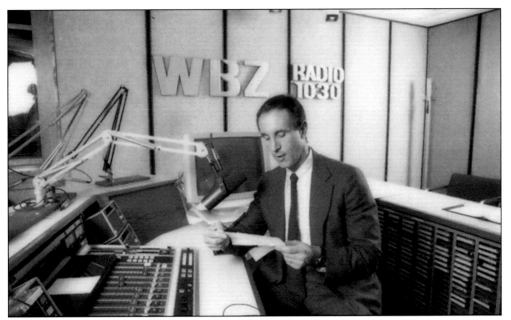

David Brudnoy came to WBZ after working at WHDH in the 1970s and WRKO in the early to mid-1980s. He was dominant in the ratings but suddenly became ill in 1994; he was HIV positive and had contracted AIDS. However, he made a remarkable recovery and returned to the air. Regrettably, he died of cancer in December 2003. To this day, former listeners still miss him. Here is Brudnoy in the WBZ studios. (Courtesy of WBZ Radio.)

This photograph shows Jon Keller, a veteran political commentator. Early in his career, he was David Brudnoy's producer at WHDH. Keller has been a commentator on WBZ-TV and hosted the radio show *Eye on Politics.* For a while, his cohost was John Henning. (Courtesy of WBZ Radio.)

Paul Sullivan, often called "Sully," was a print journalist at the *Lowell Sun* and had worked on air at WLLH. He succeeded David Brudnoy at WBZ and continued the Brudnoy tradition of a talk show that was fair yet passionate. But tragedy struck, and in 2007, Sullivan succumbed to cancer. This photograph was a WBZ publicity shot. (Courtesy of WBZ Radio.)

Dan Rea, a well-respected television reporter, spent 31 years at WBZ-TV, earning several awards. He transitioned to talk radio in late 2007, taking over the shift formerly occupied by Brudnoy and Sullivan. His program is called *Nightside*. This photograph shows him with his dog in the WBZ studio. (Courtesy of WBZ Radio.)

Steve Leveille began his career in 1977, doing news at WEEI. He joined WBZ in 1991. His overnight call-in program was so popular that in early 2009, when management cancelled it due to budget cuts, listener demands brought Leveille back. Here he is in the WBZ studio. (Courtesy of Peter Casey.)

Joe Castiglione joined the Red Sox in 1983, working with Ken Coleman. In 1991, he became the lead announcer, a position he still holds. He also teaches broadcast journalism at Northeastern University. This is one of his publicity shots. (Courtesy of WRKO Radio.)

Only a Game is an award-winning sports program that airs on WBUR-FM and is syndicated nationally. Hosted by author and broadcast journalist Bill Littlefield, it offers unique insights into the world of sports, with vignettes about everything from forgotten Negro League players to the rise of women's sports and sports as a business. This photograph shows the OAG staff in 2010; Littlefield is at center in the second row. (Courtesy of WBUR-FM.)

Dale Arnold and Michael Holley teamed up on the midday shift at WEEI in early 2005. Arnold, who joined the sports station when it began in 1991, has been a play-by-play announcer for the New England Patriots and the Boston Bruins. Holley, the station's first full-time African American host, was a sportswriter at the *Boston Globe*. This is a recent publicity photograph. (Courtesy of WEEI.)

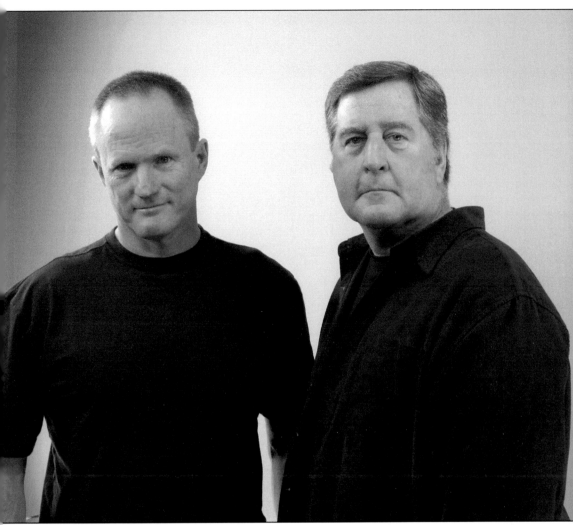

John Dennis (right), a former television sports reporter with Channel 7, and Gerry Callahan (left), a sportswriter who has written for *Sports Illustrated* and the *Boston Herald*, exemplify the "guy talk" format that is so popular on sports radio. The duo, who had been doing a midday shift, moved into the morning drive slot at WEEI in 1999, and they have remained there ever since. Known for being outspoken and controversial, they are also among the most highly rated hosts on WEEI. Here is a station publicity shot of Dennis and Callahan. (Courtesy of WEEI.)

Glenn Ordway began his career at WMLO in Beverly, then worked at WMEX (later WITS), where he became sports director. By 1982, he had become Johnny Most's partner, doing play-by-play for the Boston Celtics, who were then on WRKO. When Most retired, Ordway continued to call the Celtics games until 1995, when he became full-time program director of WEEI, in addition to hosting *The Big Show*, the station's popular afternoon drive program. Ordway is assisted by a regular cast of sportswriters and former players. A popular feature is the "whiner line," where callers leave a complaint on the show's voicemail, and the most interesting or humorous complaints are played on the air. This photograph is Ordway's publicity shot. (Courtesy of WEEI.)

Mike Adams is a veteran broadcaster who has worked on radio and television throughout New England, including six years doing sports at New England Cable News (NECN). He came to WEEI in 1993, working part-time. Ultimately, in 2005, he was given the evening shift, a show now known as *Planet Mikey*. This is his WEEI station publicity photograph. (Courtesy of WEEI.)

When 98.5 the Sports Hub (WBZ-FM) came on the air in the summer of 2009, it provided competition for WEEI. Michael Felger, a veteran sportswriter, who spent 19 years at the *Boston Herald*, and Tony "Mazz" Massarotti, a sportswriter for the *Boston Globe*, were given the afternoon drive shift at the new station. In this photograph, Mazz is on the left and Felger on the right in the Sports Hub studio. (Courtesy of WBZ-FM.)

Tom Ashbrook came to WBUR in 2001 after a career in print journalism, which included 10 years as a foreign correspondent in Japan, India, and Hong Kong. Ashbrook currently hosts a daily talk show, *On Point*, which is also syndicated nationally. Here is his station publicity photograph. (Courtesy of WBUR-FM.)

Car Talk is a quirky program that features Tom and Ray Magliozzi, two experts on all things car repair; listeners call in and describe their car's problem, and the brothers, nicknamed "Click" and "Clack," diagnose what is wrong. *Car Talk* debuted locally in 1977 and has been syndicated nationally since 1987. Here is their publicity photograph; Tom is on the right. (Courtesy of WBUR-FM.)

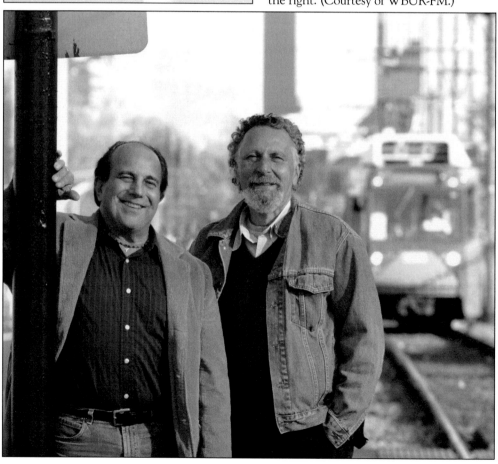

The Phantom Gourmet is a food program that also reviews restaurants. It has spent more than 15 years on Boston radio and television. It was first seen on NECN, hosted by Billy Costa, the sidekick to *Matty in the Morning* on Kiss 108. It has also been heard on WBZ Radio and, more recently, on WTKK 96.9 Talk. Those pictured are Dave, Mike, and Dan Andelman, who produce and host the program. (Courtesy of WTKK Radio.)

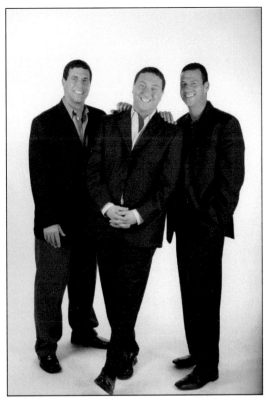

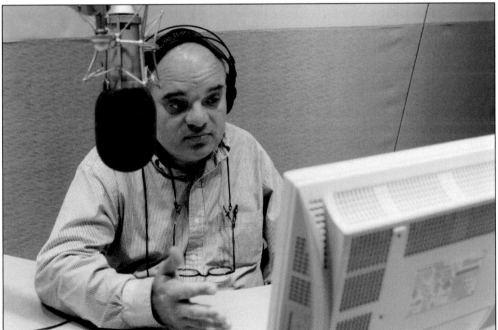

On WBUR, the local anchor of National Public Radio's highly rated *Morning Edition* is Bob Oakes. He came to WBUR after a long career at WEEI and CBS Radio, and he is pictured here in the studio. (Courtesy of WBUR-FM.)

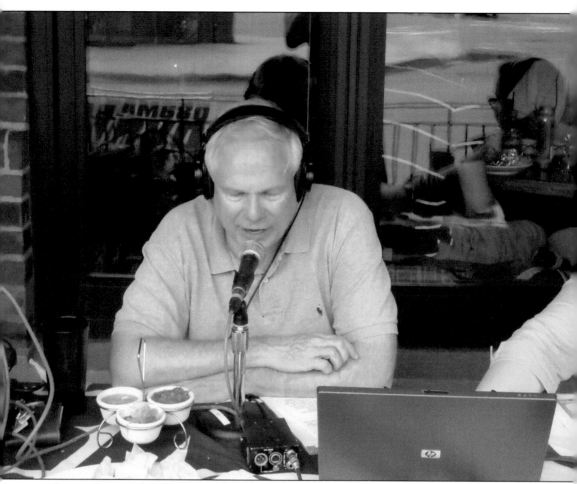

Among Boston's best known and most outspoken talk show hosts is Howie Carr. He has also spent many years in print journalism, having been a political reporter and then a columnist for the *Boston Herald*, and he also worked on local television. Carr is a conservative and a populist, highly critical of politicians, since he believes most of them are "hacks." He is also known for giving politicians he dislikes sarcastic nicknames. He is the author of *The Brothers Bulger*, which is about fugitive mobster James "Whitey" Bulger and his brother William "Billy" Bulger, a former politician. Carr has broadcast on WRKO since 1994, doing the afternoon drive shift. Here he is shown at a live broadcast. (Courtesy of WRKO.)

Jay Severin, whose real name is James Severino, is another local talk show host who is known for his outspoken conservative views. Prior to his career in radio, he served as a consultant to Republican candidates, beginning in the 1970s. His first job in radio was with WRKO, and then he went to WTKK. Severin's outspokenness has sometimes caused problems, as when he made derogatory comments about Mexicans in 2009 and was suspended. Here is his publicity photograph. (Courtesy of WTKK.)

In a lineup that is mostly conservative, Jim Braude is a proud liberal, who cohosted a political talk show on cable news in the mid-1990s. His on-air partner is Margery Eagan, a columnist for the *Boston Herald*. The two host WTKK's morning show. Although they differ on some issues, they conduct their show with courtesy. This is their station publicity photograph. (Courtesy of WTKK.)

Todd Feinburg came to WRKO in 2003 after working in the restaurant business and then doing talk shows at other area stations. The conservative talker held down the evening shift and also did a syndicated weekend show. When he was moved to mornings, his cohost was former Massachusetts speaker of the house, Tom Finneran, whose views lean more liberal. Unlike Feinburg, Finneran had little radio experience, having spent more than 25 years in politics prior to joining WRKO in 2007. At first he did the morning show by himself, before the *Tom and Todd* show debuted in January 2009. Feinburg (left) and Finneran (right) are pictured in the studio. (Courtesy of WRKO.)

Joe Martelle was one of Boston's best-loved disc jockeys during the late 1970s and throughout the 1980s. He worked at WROR (98.5 FM) for two decades, and his *Saturday Night at the Oldies* show was especially popular. Here is an undated publicity photograph of Martelle. (Courtesy of Joe Martelle.)

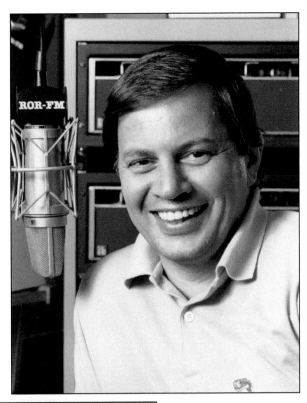

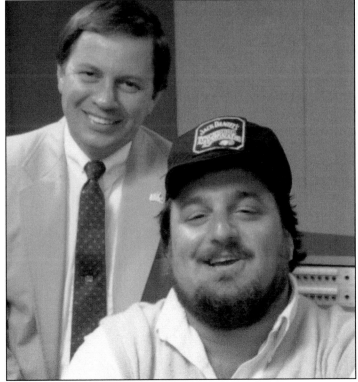

Martelle teamed up with Andy Moes in late 1982, and they enjoyed great success as a morning team for 12 years. Sadly, Andy had a heart condition, and in 2001 he died suddenly at age 50. This photograph shows the two at WROR in the mid-1980s. (Courtesy of Dave Kruh.)

One of Boston's oldies experts is Barry Scott, whose specialty is playing "records you never thought you'd hear on the radio." His *Lost 45s* program focuses on songs that were nearly hits, or have not been heard in a while; he also interviews artists of lost 45s. His show has been on Boston radio for more than 25 years, first at WZLX, then on several other stations, and finally at WODS. This photograph is his publicity shot. (Courtesy of Barry Scott.)

Bill Silver's voice was often heard on Boston radio in the 1980s, most notably at WROR, which was where he did the midday shift for several years. He also worked at WHDH and WMJX. He was heard on a number of commercials, especially for Ginsu knives. This mid-1980s photograph was taken at WROR. (Courtesy of Dave Kruh.)

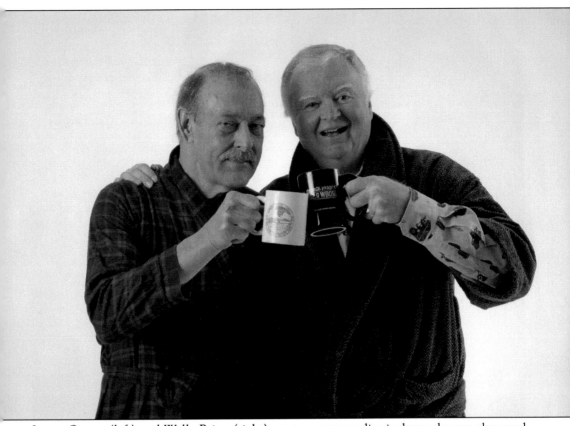

Loren Owens (left) and Wally Brine (right) are two veteran disc jockeys who are also good friends. They have been a successful morning team since the early 1980s and still continue to make Boston radio listeners smile. Loren found radio during his college years in Indiana; Wally comes from a radio family—his dad was famous Providence radio host "Salty" Brine. The duo debuted at WVBF, an adult-contemporary station, in 1981. When it changed format to country music in early 1993; they remained on the air, until they moved over to the new WROR 105.7, which is where they can still be heard. This is one of their publicity shots. (Courtesy of Greater Media, Boston.)

In the 1970s and early 1980s, Boston stations began hiring more female disc jockeys. Karen Blake's radio career began when she interned at Kiss 108. Program director Sunny Joe White then gave her some on-air work, and she became known for her *Night People Report.* She then moved to WZOU (today JAM'N 94.5), as part of their morning zoo, where she was the "Madam." The popular disc jockey later did country at WKLB and joined WODS in 2005. In this photograph, she is shown in the studio. (Courtesy of WODS.)

Another successful female disc jockey is Mauzy Stafford. An experienced voice-over artist who has been heard on many commercials, she has also been on the air at WKLB, WCOZ, and WODS. Most recently, she did weekends at WROR. This undated photograph shows her at WODS. (Courtesy of Dave Kruh.)

Candy O'Terry is one of Boston's most accomplished—and busiest—female announcers. She did her first air work at WMJX in 1991. By 1992, she was developing a public affairs program called *Exceptional Women*, a 30-minute weekly feature about women with inspiring achievements. She and colleague Gay Vernon cohost it, and the program has won a number of awards. In addition to being on the air at WMJX, she was promoted to assistant program director in 2001. These days she can also be heard giving traffic reports on sister stations WKLB and WTKK. O'Terry has served as the New England president of AFTRA. She is also a trained vocalist who has sung commercial jingles and also produced several recordings. This is her official publicity photograph. (Courtesy of Candy O'Terry.)

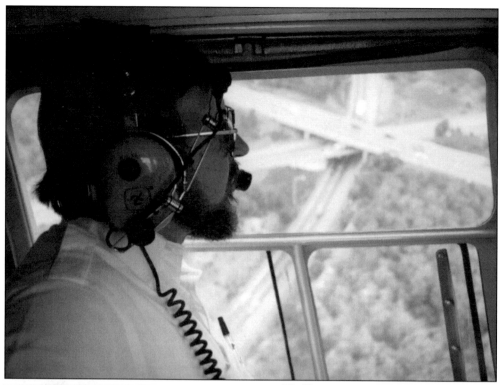

Traffic reports remain an important element on radio. Malcolm Alter is a veteran reporter who began working for *Metro Traffic* in 1982. By 1984, he was in the traffic helicopter, reporting for WRKO and later for WROR. When Joe Green retired in 1995, Alter did traffic reports for WBZ. These days, Alter again reports for WRKO. In this mid-1980s photograph, Alter is seen in the helicopter. (Courtesy of Malcolm Alter.)

Rich Kirkland is another experienced traffic reporter on Boston radio. A former news director at WRKO in the late 1980s, Kirkland worked for *Metro Traffic* on several occasions. Today he is again one of the reporters who does *Traffic on the Threes* on WBZ. This photograph is Kirkland's publicity shot. (Courtesy of Rich Kirkland.)

Before he became a station owner, Bob Bittner was a disc jockey and station manager at WNTN in Newton. He also was a disc jockey at WBOS-FM when it played disco. In 1991, Bittner purchased what was then WLVG (which had been WCAS years earlier). He renamed it WJIB, using call letters that harkened back to WJIB-FM, a beautiful music station dominant in the late 1960s and during the 1970s. WJIB-FM used the slogan "Easy as the Breeze." Today WJIB-AM is at 740 and is commercial-free. Weekend paid programming initially supported the station, but in 2007, Bittner moved to a listener-donation model and eliminated leased programs on weekends. He has been successful in doing WJIB his way; he also owns WJTO, a station in Bath, Maine. This photograph shows Bittner with T-shirts from both stations. (Courtesy of Bob Bittner.)

There were several efforts to do country in Boston in the 1950s and 1960s. In the early 1990s, Boston finally got a successful country FM, WCLB at 105.7, which is now WKLB at 102.5. Country star Shania Twain is seen visiting the station in 2003. Those pictured are, from left to right, Melissa Gaudette, Marianne Mooney, Shania Twain, WKLB music director Ginny Rogers, and Carolyn Kruse. In the back is WKLB program director Mike Brophey. (Courtesy of Ginny Rogers.)

Emily Rooney comes from a media family; her father, Andy, is a veteran television commentator, and her brother Brian was a network news reporter. She is the creator and host of the award-winning local television program *Greater Boston*. Rooney had worked mainly in television news; however, in January 2010, she debuted her new radio program on WGBH. This photograph is her WGBH publicity shot. (Courtesy of WGBH.)

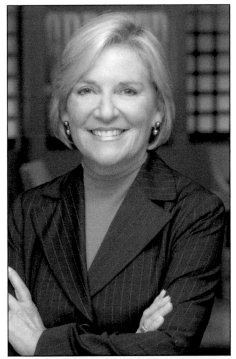

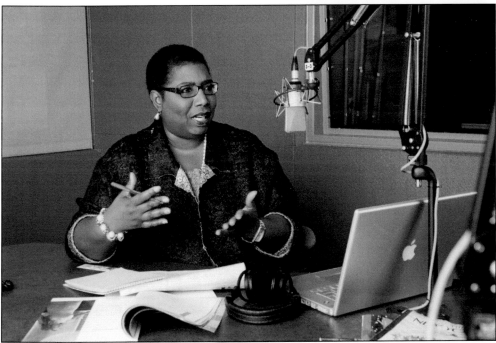

Callie Crossley has been a journalist, an award-winning producer of documentaries (with expertise in black history), a television producer, and a panelist on WGBH-TV's media criticism program *Beat the Press*. She currently has her own talk show on WGBH Radio, featuring what she calls "intelligent talk," focusing on current events, arts, and culture. In this 2010 photograph, she is seen at the radio microphone. (Courtesy of Callie Crossley.)

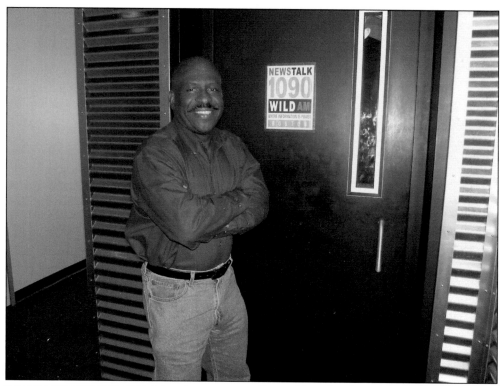

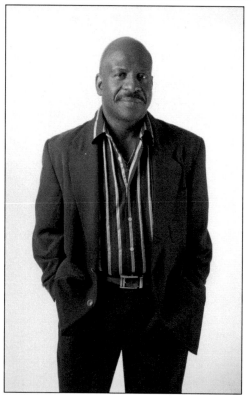

Jimmy Myers has been involved with broadcasting for more than three decades, on both radio and television. An experienced sportscaster and sports producer, he has worked at such local stations as WBZ and WEEI. In 2006, he became the morning show host at WILD, but his tenure there was short-lived, because the station was sold and the format changed. In this 2006 photograph, Myers is seen at the WILD studios. (Courtesy of Tony Bennis.)

Jimmy Myers is currently on the air doing a weekend talk show for WTKK, which is where he discusses a wide range of topics from sports to politics. This is his official station publicity photograph. (Courtesy of WTKK.)

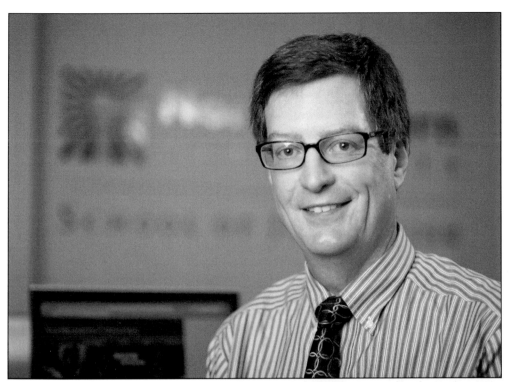

Dan Kennedy has long been known as a media critic, writing for the *Boston Phoenix* and then for his blog *Media Nation*. Kennedy's insightful comments about Boston radio and television are frequently quoted, and he has been a pundit on WGBH-TV as well as a guest on a number of radio talk shows. This is his WGBH publicity photograph. (Courtesy of Dan Kennedy.)

Jordan Rich has been heard on Boston radio for over three decades at such stations as WRKO, WLLH, and WSSH-FM. At WSSH-FM, he had the morning shift for 12 years. A skilled interviewer, he joined WBZ in 1996, doing weekend shows and filling in as needed. He also runs his own audio production company. This is his publicity photograph. (Courtesy of WBZ Radio.)

WBZ lost two of its best known personalities to retirement during 2009. In January, veteran morning sports anchor Gil Santos did his final broadcast, after a career of 38 years as part of the morning team. However, Santos, who was also the voice of the New England Patriots, planned to continue doing game broadcasts on WBCN, which were soon moved to the new WBZ-FM. In the photograph at left, Santos is being applauded by his WBZ colleagues on his final day. He is seen with his wife, Roberta. In the photograph below, veteran morning news anchor Gary LaPierre is preparing to do the news on WBZ Radio for the final time in late December. (Left, courtesy of Allan E. Dines/ Northstar Photography; below, courtesy of WBZ Radio.)

Prior to coming over to WBZ in 1993, Peter Casey was a producer and assistant program director at WHDH. He became WBZ's program director in 1996. In this 2007 photograph, Casey is shown with CBS-TV news anchor Katie Couric, who was visiting WBZ. (Courtesy of WBZ Radio.)

After spending more than four decades on WBZ, Gary LaPierre announced that he had decided to retire. His replacement was veteran news anchor Ed Walsh, who had been on the air at WBZ's sister station, WCBS, in New York. In late December 2006, an era ended at WBZ. For LaPierre's final show, all staff members dressed formally, with men wearing tuxedos and women wearing dresses. His last show was also available on a live webcast. Here are two photographs from LaPierre's final WBZ show. In the first, Ed Walsh is on the left, and LaPierre is on the right. In the second, Ed wishes Gary good luck with his retirement, and the two radio news anchors shake hands. (Both, courtesy of WBZ Radio.)

A Brief Boston Radio Retrospective

May 20, 1921: Greater Boston's first station, 1XE (later WGI) begins a daily schedule.

September 19, 1921: WBZ, then in Springfield, first station to receive a commercial license, begins broadcasting. (Its Boston studio, WBZA, opens late February 1924.)

July 31, 1922: WNAC (today WRKO) in Boston debuts from the Shepard Department Store.

September 29, 1924: WEEI, owned by the Edison Electric Illuminating Company, goes on the air.

June 20, 1929: WHDH debuts in Gloucester; it will open a Boston studio in November 1930.

October 18, 1934: WMEX goes on the air. (In the late 1950s, it becomes an important Top 40 station.)

July 24, 1939: W1XOJ is Greater Boston's first FM station.

December 18, 1940: W1XOJ is linked with a New Hampshire station, W1XER, to create the first FM network.

November 14, 1949: WERS at Emerson College is Boston's first noncommercial FM station.

September 5, 1957: The former WBMS becomes WILD Radio; it will become Boston's first black music station.

March 13, 1967: The former WNAC becomes WRKO, a Top 40 station.

March 15, 1968: WBCN-FM, a classical music station, begins playing rock music late at night. It will soon become an album-rocker (playing album tracks rather than Top 40 singles).

October 29, 1985: WZLX-FM, a classic rock station, makes its debut.

September 3, 1991: WEEI switches to a sports talk format.

September 19, 1996: WBZ Radio celebrates its 75th anniversary.

Discover Thousands of Local History Books
Featuring Millions of Vintage Images

Arcadia Publishing, the leading local history publisher in the United States, is committed to making history accessible and meaningful through publishing books that celebrate and preserve the heritage of America's people and places.

Find more books like this at
www.arcadiapublishing.com

Search for your hometown history, your old stomping grounds, and even your favorite sports team.